CELIA SCOTT

black dog
publishing

london uk

CELIA SCOTT

For Bob

Contents

Portrait of the Artist

I remember one of my first paintings I did there, *Venice Imagined* (I had never been to Venice). Later, I tried painting from observation.

I always enjoyed art and maths when I was at the Cambridgeshire High School for Girls because it seemed you didn't have to do too much learning by rote in order to do well.

I remember one of my first paintings I did there, *Venice Imagined* (I had never been to Venice). Later, I tried painting from observation. There were the usual life drawings and paintings, and a series based on shadows and reflections: mirrors, glass, and *Bottles*.

Painting was an escape. I used to be packed off for the long summer vacations to my uncle Wayland, who lived in a cabanon making harpsichords, on Meraud Guinness Guevara's estate at La Tour de César, just outside Aix-en-Provence, in the south of France.

I slept in my own tiny cabanon, which was just big enough to take a bed. After breakfast on a massive stone table overlooking the mountain Sainte Victoire, I was left to my own devices for most of the day. This meant roaming around and trying to paint like Cézanne. Lunch was up at the big house, where Meraud painted. Dinners were back at the cabanon, usually out on the other terrace at a long table overlooking the lights of the town of Aix. In summer there was a constant stream of visitors; artists, poets, writers, musicians. One morning after a congenial dinner we found that David Gascoine had left his little black notebook behind. We all thought it would be full of poetry or drawings, but were disappointed to find that it contained nothing but recipes.

On my journeys back from Aix to Cambridge I sometimes stayed with friends in Paris, and spent days in the Louvre looking at nineteenth century French painting, especially Delecroix. When I was 16, I won 25 pounds on a Premium Bond, which enabled me to travel to the Hague, for a Vermeer retrospective, and on to Paris, for a Delacroix retrospective.

Venice Imagined, 1956, Celia Scott, powder colour on paper, 55 x 37 cm.

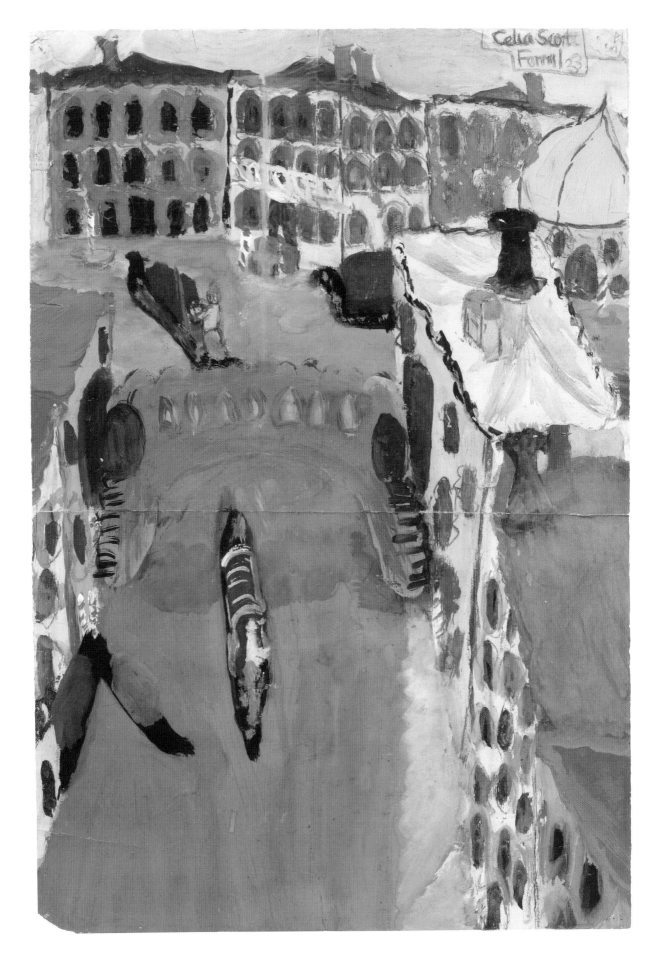

11

Figure in Space, 1966,
Celia Scott, charcoal on paper,
53 x 37 cm.

Opposite: La Tour de César,
Celia Scott, 1963, gouache on paper,
36 x 49 cm.

Back in Cambridge, art began to take over. I had three clever brothers and it was one thing I could do that the rest of my family could not. I spent a lot of my spare time drawing. Sometimes I went to a pub to draw, and students often bought me a drink in exchange for a drawing of themselves. Sometimes I made terracotta heads.

Art is not easy to adopt as a career with full parental approval, you have to be committed. In spite of the arguments, my parents consented, at least to an initial step, so I was sent off to art school at the Bath Academy of Art, which was situated at Corsham, in the West Country, to do a two-year pre-diploma course in two terms. I had had a pretty free-ranging life at a day school in Cambridge, a university town at that time, brimming with mostly male students. So it was a shock to be a boarder, to be sharing a bedroom and to be locked in at nine in the evening. The year before there had been a scandal, with several of the faculty having intimate relations with some of the female students.

Classes at Corsham were very disciplined and there was always a drive towards abstraction. In drawing, I studied the figure in space, looking at Giacometti, and in painting I continued my studies of reflections and glass in a more hard-edged way. I also made some sculpture, a plaster head of an old man, in which I emphasised the angles of the face, in a somewhat cubistic way, with slightly abstracted planes. It was nothing much to do with portraiture. Later, I found this head on my mother's dust heap, rescued it, cleaned it up—it was green with verdigris—brought it home and placed it on my mantelpiece.

My parents weren't altogether so keen on my studying art, they thought I should do something useful, something more likely to lead to a job.

My time at Corsham had felt so restricted that I agreed to go to University College London, to study architecture at the Bartlett.

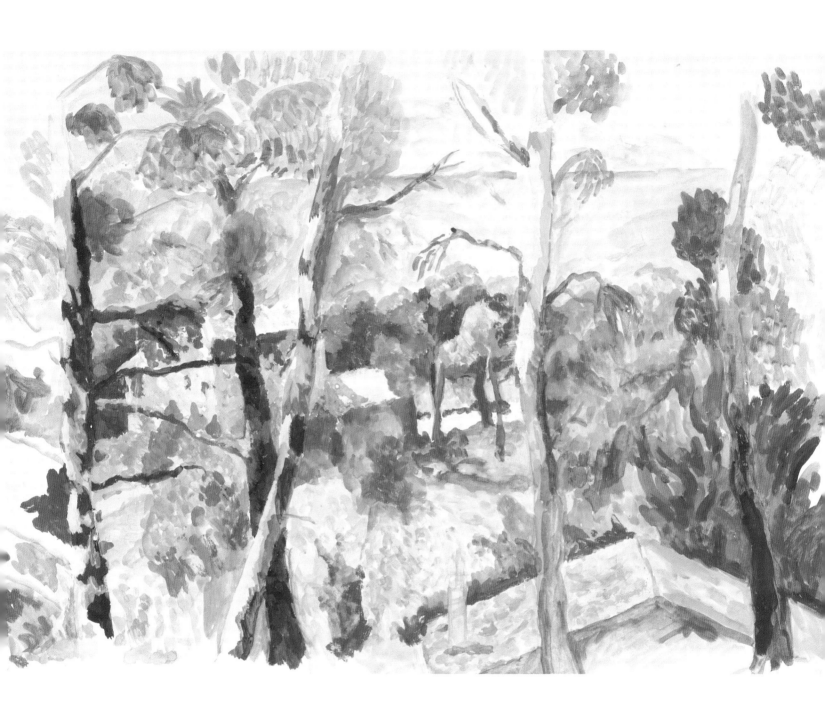

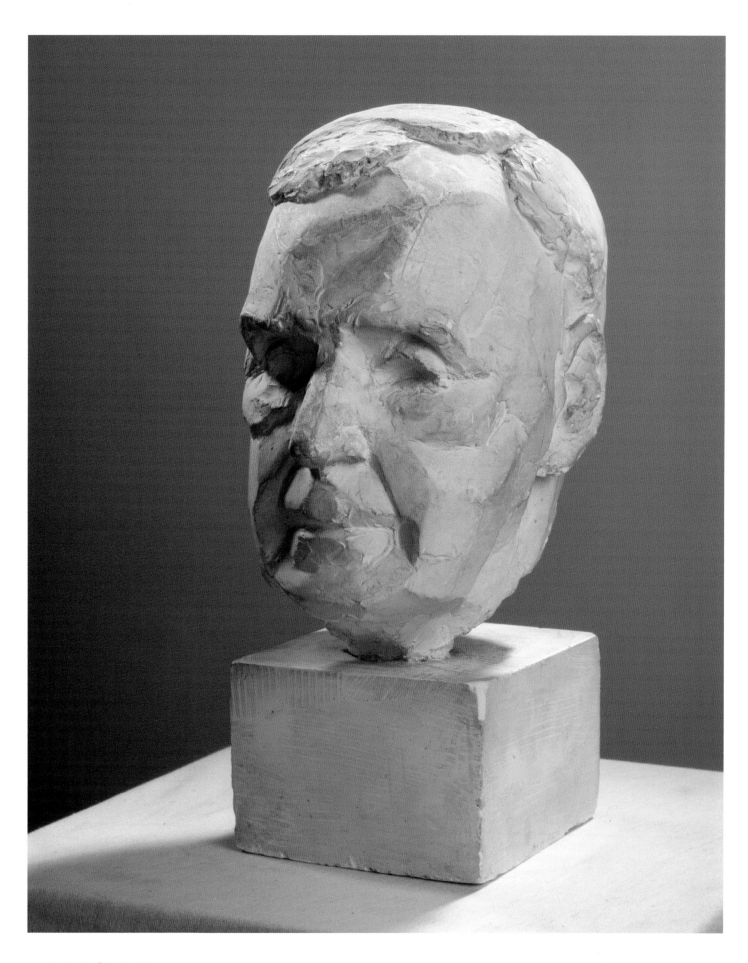

So after some months travelling in the Middle East, that's what I did. The compensation was that the Bartlett, in those days, was next door to the Slade, and I used to go in there frequently to explore and see what I could see, and sometimes go to lectures and so on.

I remember hearing Anthony Blunt give lectures on Picasso. He was really good. And of course I was able to attend life-drawing classes, a concession that was open to architecture students. There weren't so many Slade students in those classes, it must have fallen out of favour; that kind of interest seems to come and go in waves.

I qualified as an architect, and faced up to the business of getting a job. I worked for a firm called Castle Park Dean Hook, where through Christopher Dean's support I was able to design a terrace of houses with front doors onto the street, and granny flats, not in the basement, but on the top approached by a lift. It was rationalist in style. The top story sloped gently with the angle of the street, so the scheme was both traditional (with front doors) and unexpected, with a sloping top floor. It got built, and still looks alright.

Then I got a job with Norman Foster, where I worked on a scheme for Hammersmith: a ring of offices with an inflatable roof over the space in the middle, and bus and tube stations underneath, filling the whole area of the roundabout. It was an interesting project, but—because it was very radical—it succumbed to politics and was never built. Working with Norman Foster for over two years was a fascinating experience. Later, I worked for Edward Jones of Dixon Jones, and he became a good friend.

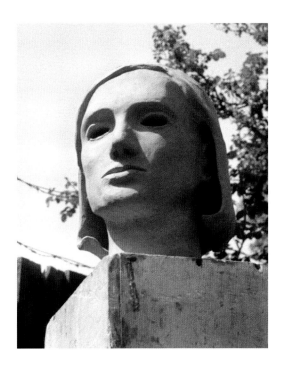

Glass, 1966, Celia Scott, oil
on canvas, 61 x 51 cm.

Opposite: Bottles, 1963, Celia Scott,
powder colour on paper, 48 x 51 cm.

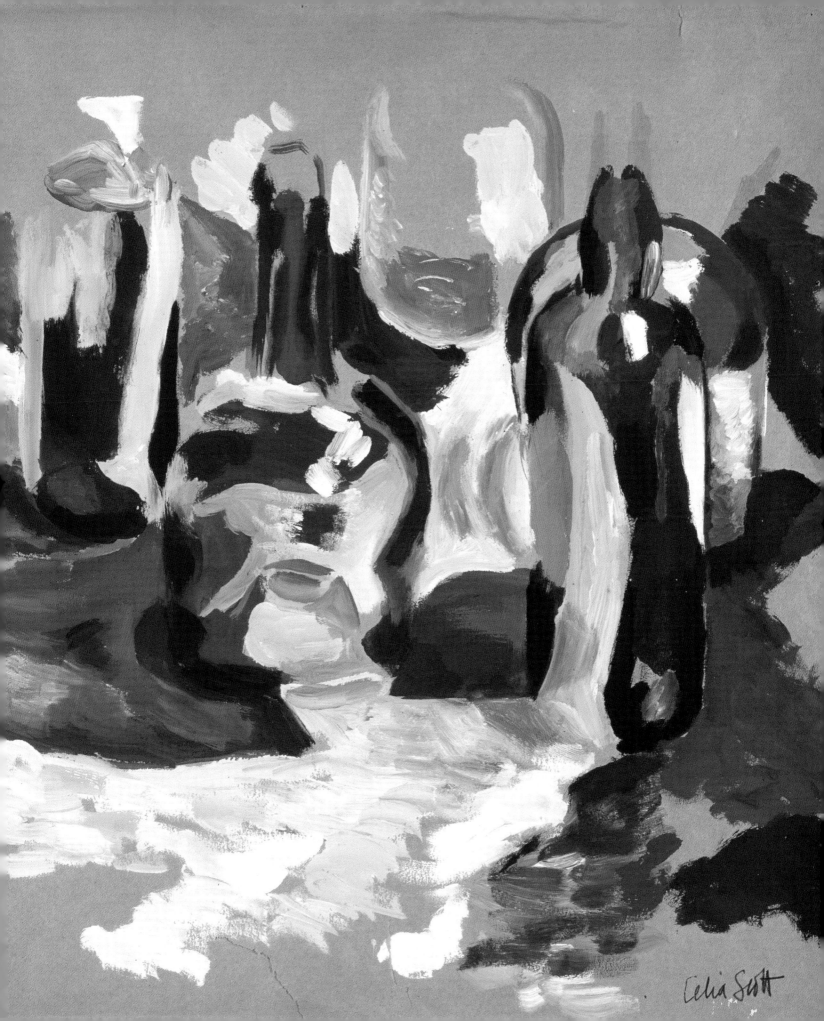

Leon Krier

It seemed that using the bust shape was like putting forward the public face of the sitter, whereas the details of the face were concerned with the particularity of the person.

On one occasion, the Kriers came to dinner, and the minute Leon was in the room he marched up to the mantelpiece, where I had placed the head I rescued from my mother's dust heap, and said: "Who did this?". I owned up, and he immediately said: "You must do one of me". In this way I got started, not on only one, but on a whole series of heads.

So Leon came for two-hour sittings every week or two for a period of four months. I took photographs and measurements, setting up a stand in the living room of my home, which used to be Barbara Hepworth's studio. I built an armature and set to work in clay. Between the sittings I worked on it for long hours, mainly at night. Meanwhile, friends and colleagues came and went, discussing ideas about architecture and the public realm.

Why did it turn out to be the way it did? Well, there were ideas in the air at this time that led to the eventual form of the head. There was the idea that abstraction had become too introverted and elitist, incomprehensible to ordinary people. There were two marked trends in figurative architecture and art, one that drew inspiration from tradition, the other from popular culture. In architecture, these trends were exemplified by Aldo Rossi and Robert Venturi, whereas in art there were George Segal, Tom Otterness, Duane Hanson and Andy Warhol. Krier himself was a polemical figure, he stood up strongly for his ideas, and he was a character. He was an outsider who had arrived in London and was making a polemic against corporate architects and planners' view of the post-war city. He appreciated Le Corbusier and modernism but he was also very keen on the sort of German neo-classicism that came into fashion around 1830, with people like Schinkel, Schadow and the Swede, Thorvaldsen. There was something fascinating about the way Schinkel revived ancient forms, and then they turned out to be modern, that is they came to represent his moment in time very clearly. They were at once classical, romantic and modern.

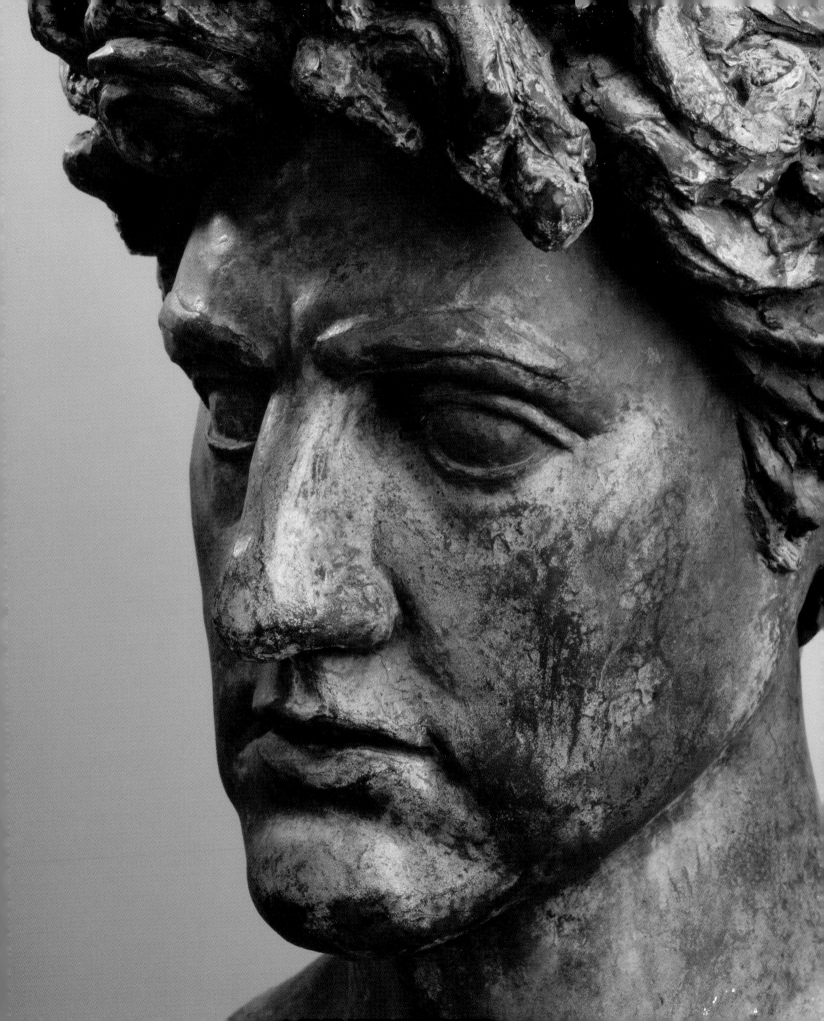

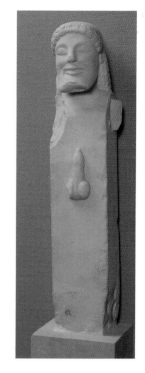

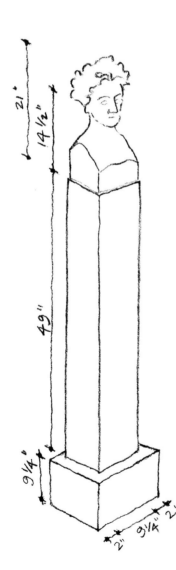

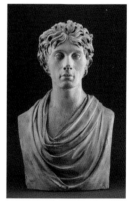

There was a buzz of excitement when you thought of history as a succession of present moments, not as a completely dusty past. Leon was into all of that, especially the mixture of classicism and romanticism that came with Schinkel.

While studying architecture at the Bartlett, I had been taught history by Reyner Banham, and he made it clear that history was dead. He taught us nothing about what happened before modernism. By forbidding history he made it more interesting for me. One is always attracted to what is forbidden. And, instinctively, I didn't believe in the tabula rasa, you couldn't wipe out what you already knew.

At around the time that I was doing Leon's head, Alan Colquhoun had written an article about building types, and how architects should openly acknowledge historical precedent. With all these conversations going on around me, I thought the head of Leon might somehow be an analogy for his ideas. The cubists had looked at the primitive in order to make things strange. I found myself looking at the classical in order to make things strange.

I began to think about the bust shape in itself. What did it imply? It seemed that using the bust shape was like putting forward the public face of the sitter, whereas the details of the face were concerned with the particularity of the person. Portraiture called for a likeness, but an absolute likeness was out of the question, it certainly didn't work with the death mask. There had to be a sufficient resemblance, true, but it wasn't just a question of resemblance, nor was it a question of the artist's need for self-expression. There was something else, and I wanted to find out what this something else could be.

It had something to do with convention, the stereotype that was imposed by the viewer, the degree to which the head was somewhat expected. The expected, of course, was anathema to the idea of the original artist, much more to the idea of the avant garde artist, so artists tend to shy away from it. Pretty well all artists today want to be thought of as original, if not avant garde. Lots of people are nervous about portrait heads, treating them as effigies that make one feel uncomfortable. It's true that you cannot ignore this aspect of a head, but there is something else involved, something that has to do with the power of the head as art, its innate quality, its presence. This is something difficult to convey in a photograph, you have to be in a room with the object to feel its intensity. This was what I wanted to investigate.

I became interested in the classical, and the neo-classical. I was intrigued by the idea that in ancient Greece the individual was not so important as his social role as citizen in the Greek state. I became interested in the herm, that form which was both real and abstract, an abstract monument incorporating a figure. I decided to go back to Cambridge, the domain of my Classics don mother from whom I had escaped, and went to the

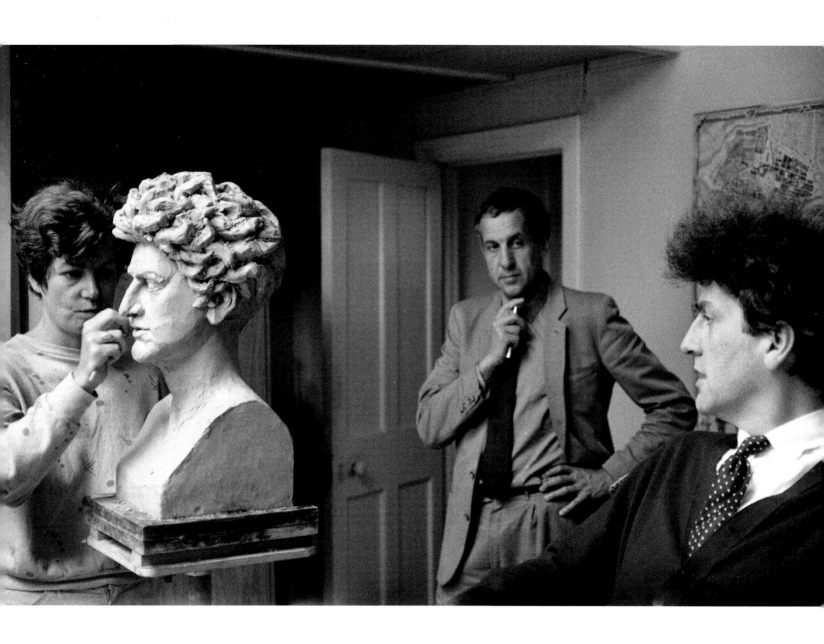

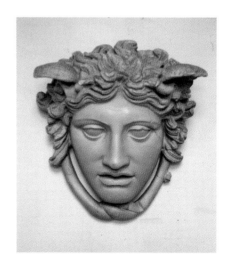

Archaeology Department Museum to make drawings of the plaster heads. I was fascinated by the way eyes were often done in a manner that made them look visionary. I went to Rome, and spent hours in the Capitoline Museum looking at Roman heads, which seemed to be very realistic, yet were properly monumental. They were obviously intended to be realistic, but once the sitter was dead and gone, no-one could judge that aspect. Yet you still felt that some were good heads. The monumental itself was of interest when you thought of it functionally as something that could represent you when you were dead, something by which you could be remembered. All of these ideas were mulling about in my head.

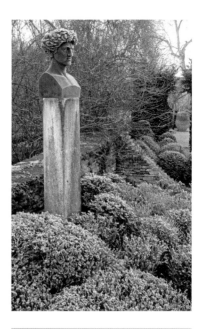

But there was another layer of interest. Krier had peculiar hair, it stood up around his face like a halo, yet it was quite thin and wispy. How could one render his hair in clay? Clay is such a thick material, this was a problem. I think this was quite important in leading me to the use of a convention. The head of Medusa became a powerful image. By doing something that was deliberately stylised, I could represent Krier's ideas rather than just his appearance.

So it's less personal, as a portrait, than some of the later ones. As an object, I think it is quite powerful. That in itself was a discovery, the realisation that whatever the surface ideas were, the ideas that entered into the conception, there was another level where it either worked or it didn't.

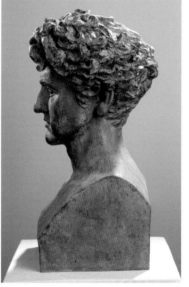

Finally, the head was cast in bronze, with an antique weathered green patina. Leon paid the foundry for the cast, took the bronze and plaster casts and the best of my photographs of himself and in return gave me two plaster casts from the Munich Glyptotek, one of the monstrous Medusa, and one of Alexander the Great. Recently that same Medusa fell from her position on the wall high up in Mall Studios and shattered into tiny fragments.

So, by working on the bust of Leon Krier, I was forced to consider some of the problems of doing portraiture, and the project began to interest me a good deal. It so happened that in my circle of friends, who happened to be mostly architects, there were a few who didn't mind being immortalised in bronze.

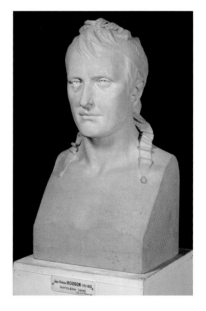

Right top: Leon Krier in HRH the
Prince of Wales' garden at Highgrove.

Right middle: Leon Krier, profile, 1981,
Celia Scott, bronze, 53 x 28 x 28 cm.

Right bottom: Napoleon, 1806,
JA Houdon, terracotta, 51 cm high.

Opposite: Leon Krier, 1981,
Celia Scott, bronze, 53 x 28 x 28 cm,
private collection.

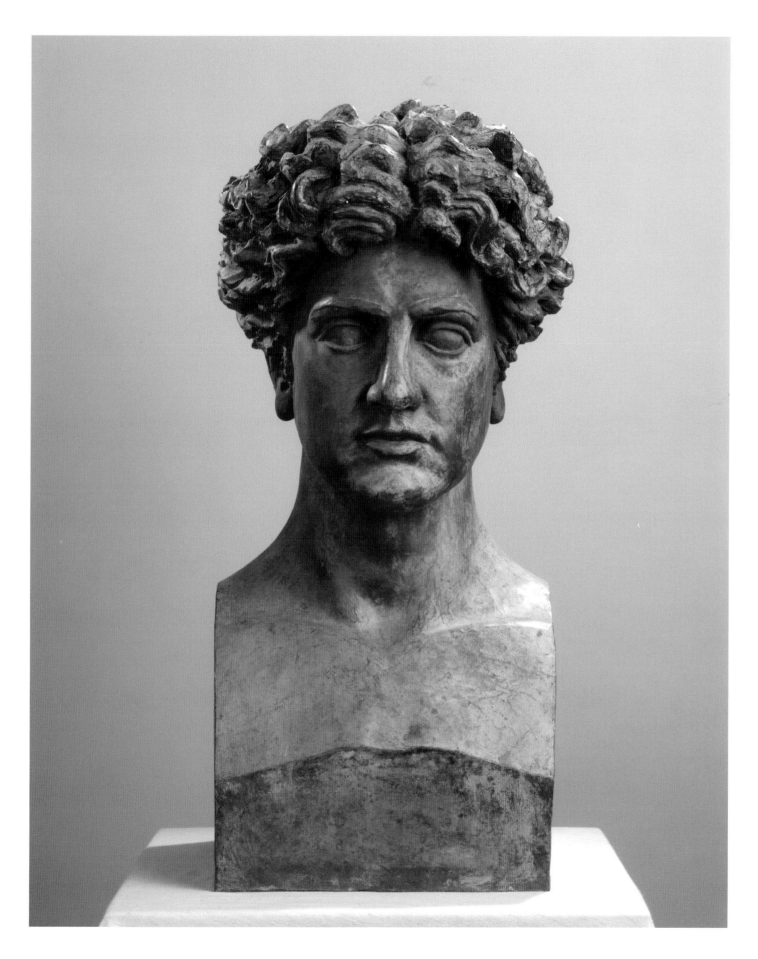

Edward Jones

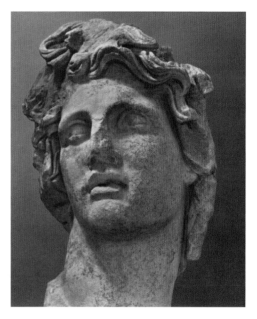

Head of Helios, second century
BC, marble, height 55 cm.

Opposite: Edward Jones, 1982,
Celia Scott, detail of bronze bust.

Suddenly Edward's face slotted into place. It would be both beautiful and strong, and that is how it came out.

First, I approached Edward Jones. A friend who was interested in the project and whose work I admired. At this time he was struggling to make ends meet, teaching and doing architectural competitions. During some of the 13 sittings, which took place over a period of nine months, he was sketching *partis* for his entry for the Mississauga Town Hall in Canada, a competition which he later won and got built.

He was undeniably handsome, and even somewhat beautiful. So I was puzzled as to how to deal with this, because as an architect I knew he was incredibly applied and hands-on, working long hours, by drawing. I already had my plaster bust of Alexander at hand, though another version of this seemed a better model. Then I thought of Balzac's ideas of types, and began to search in a different way. Finally I thought of Mick Jagger, whose face was both frenzied and attractive. Suddenly, Edward's face slotted into place, it would be both beautiful and strong, and that is how it came out. The shape of the bust, which had started out as more or less square (like Leon's) now became curved and undercut, and then the whole head looked right. By turning his head, it was possible to suggest a certain animation, a degree of life.

He paid for the bronze and a plaster cast and in exchange gave me a replica of Aphrodite's head from the British Museum.

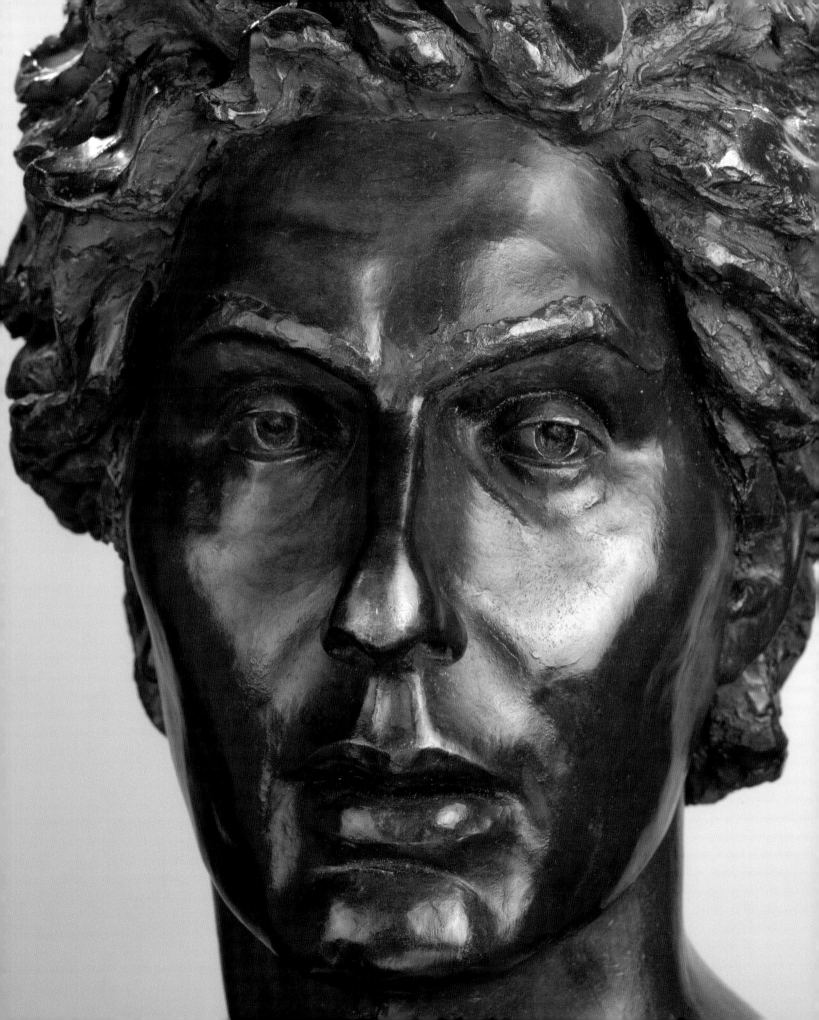

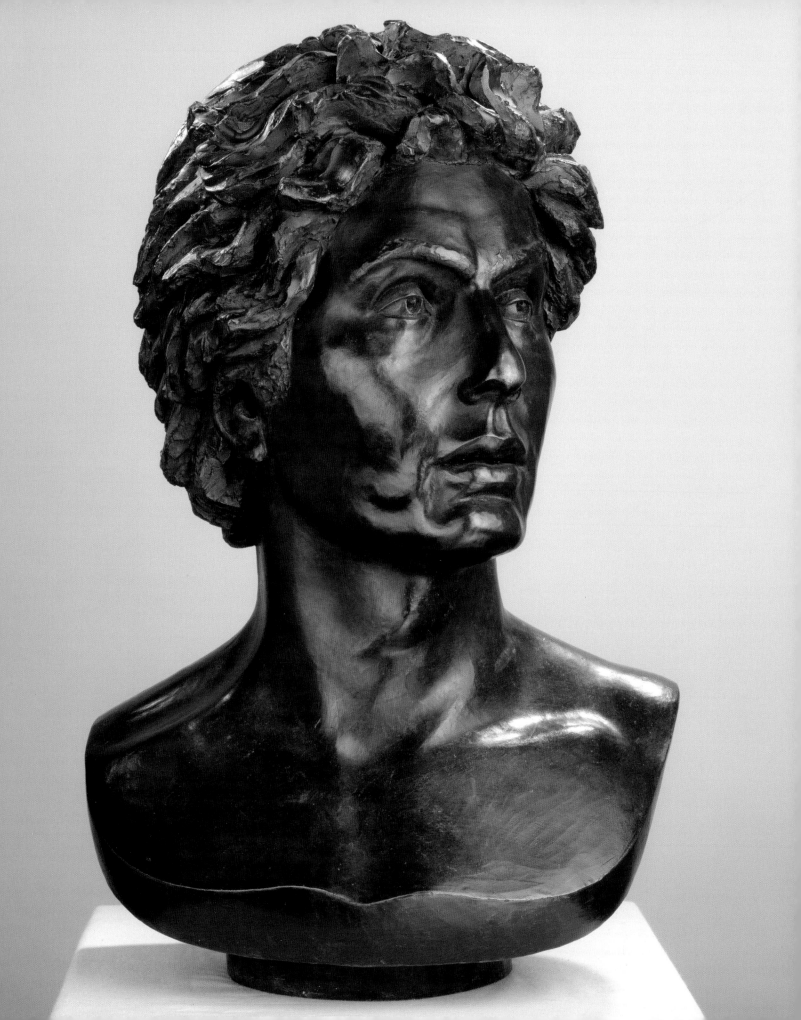

Opposite: Edward Jones, 1982, Celia Scott, bronze, 52 x 37 x 23 cm, private collection.

Left: A young Mick Jagger, c 1964, photograph by John Hopkins.

Right: Edward Jones, 1982, Celia Scott, plaster, 52 x 37 x 23 cm, artist's collection.

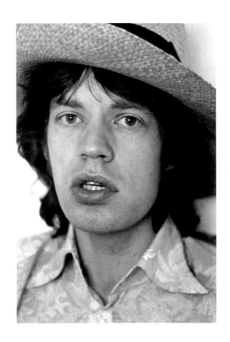

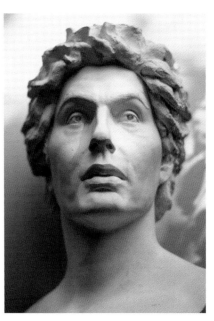

John Miller

Aphrodite-type Goddess, bronze head from Sadagh in the British Museum, 43 x 30 x 25 cm, resin replica given to Scott by Jones.

Opposite: John Miller, 1982, bronze, detail, with green patina caused by natural weathering in the open air.

An odd thing happens with these heads: at first they seem to be just traditional busts; then you recognise the person, and this can be quite shocking. It is as if they have come alive.

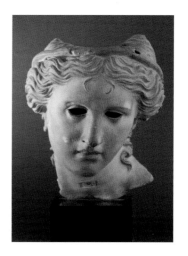

Next I chose to do John Miller, another friend who was keen to sit. He had the look of an experienced architect, someone who had been through a lot of tribulation, who had become something of a seer. As I remember it, he was not a problem to do. He is naturally social, and chatty, but also in a way he fitted all those ideas about creating the monumental. His work is modernist, it's true, but with a certain general quality that allows it to work with the old, his work at the National Gallery of Scotland shows this quality. So he comes out looking like an antique head, with a square torso like Leon's.

An odd thing that happens with these heads: at first they seem to be just traditional busts; then you recognise the person, and this can be quite shocking, it is as if they have come alive. Sometimes the bust form looks quite alien, or hard, but with John Miller, bust and all, he looks quite jovial, so it suits him.

Two more ideas seemed to be appropriate: I left his eyes blank, as if they had been plundered (in ancient times the eyes were sometimes made of jewels or pearls and were ripped out by thieves), and I thought very hard about the patina, and tried out a green look which adds to the antique effect. In nature, a bronze left out of doors will eventually weather to green. So this bust makes a kind of history that is quite false, since John in the flesh isn't at all antiquarian. Yet, though it's a fiction, it does make him larger than life, it gives him a different presence that doesn't seem altogether wrong.

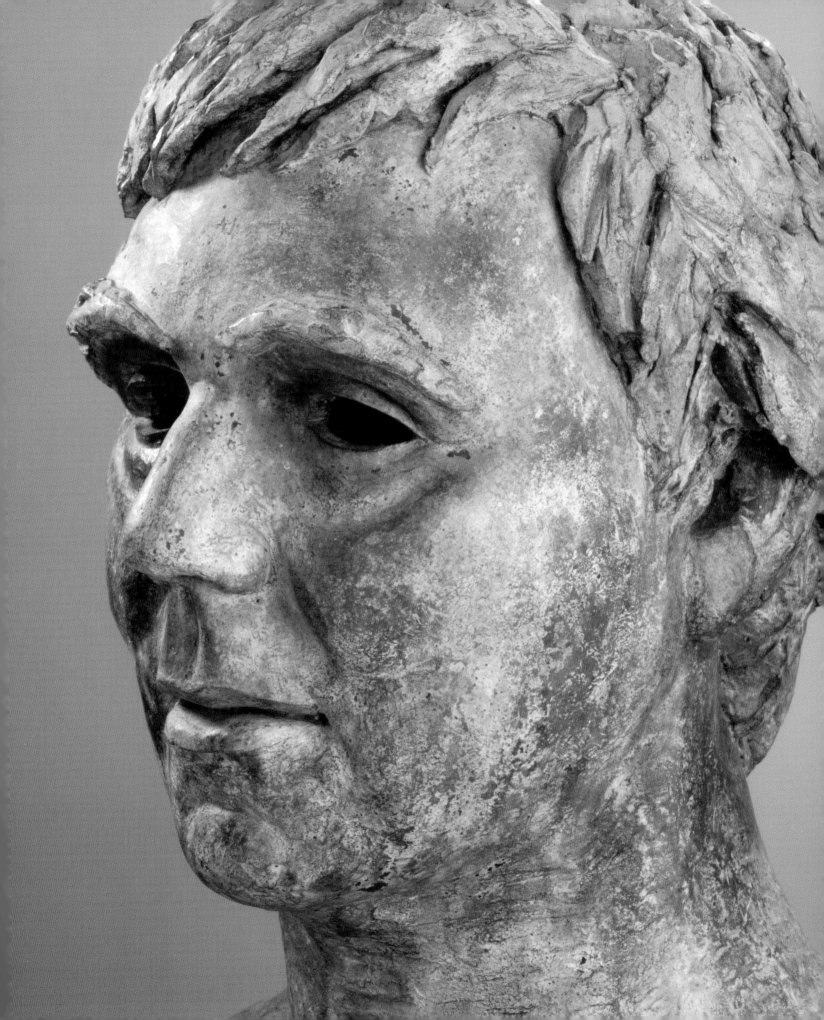

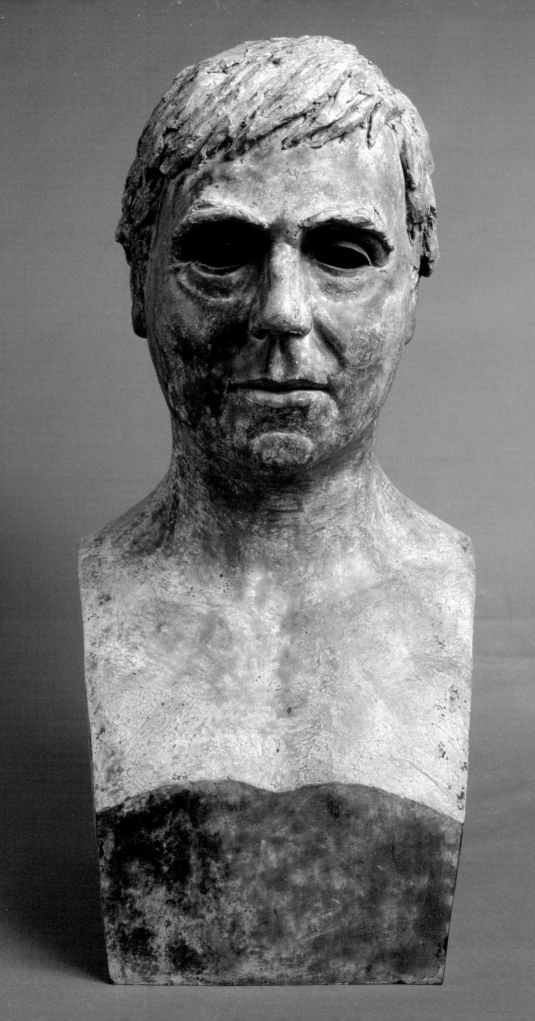

Opposite: John Miller, 1982, bronze,
60 x 30 x 23 cm, private collection.

John Miller sitting for Scott in Mall
Studios, 8 May 1982.

Alan Colquhoun

With him, it is the intensity of the intellectual that comes through. So it wasn't difficult to find him in the form of a Roman senator, as someone like Seneca who appreciated the power of argument, but was also reconciled to the futility of words.

Alan Colquhoun, I thought about as a critic. He was an architect in partnership with John Miller as Colquhoun and Miller. At the time I made this head he was Professor of Architecture at Princeton and had become fiercely theoretical. So he has become more of a writer and critic, and seemed to fall in with similar ideas. He had written an interesting essay about typology, and this made him part of the argument, it related him to the Krier interest in the Classical, Romantic and Modern.

By now I had developed something of a way of working, and I had begun to realise that drawings were as useful as photographs, if not more so. Again I took measurements of critical points of his head with callipers, and this time recorded them on drawings. He came for a total of 14 sittings over three or four months, and the conversations were always interesting.

Alan Colquhoun, 1983,
Celia Scott, bronze,
53 x 30 x 23 cm,
private collection.

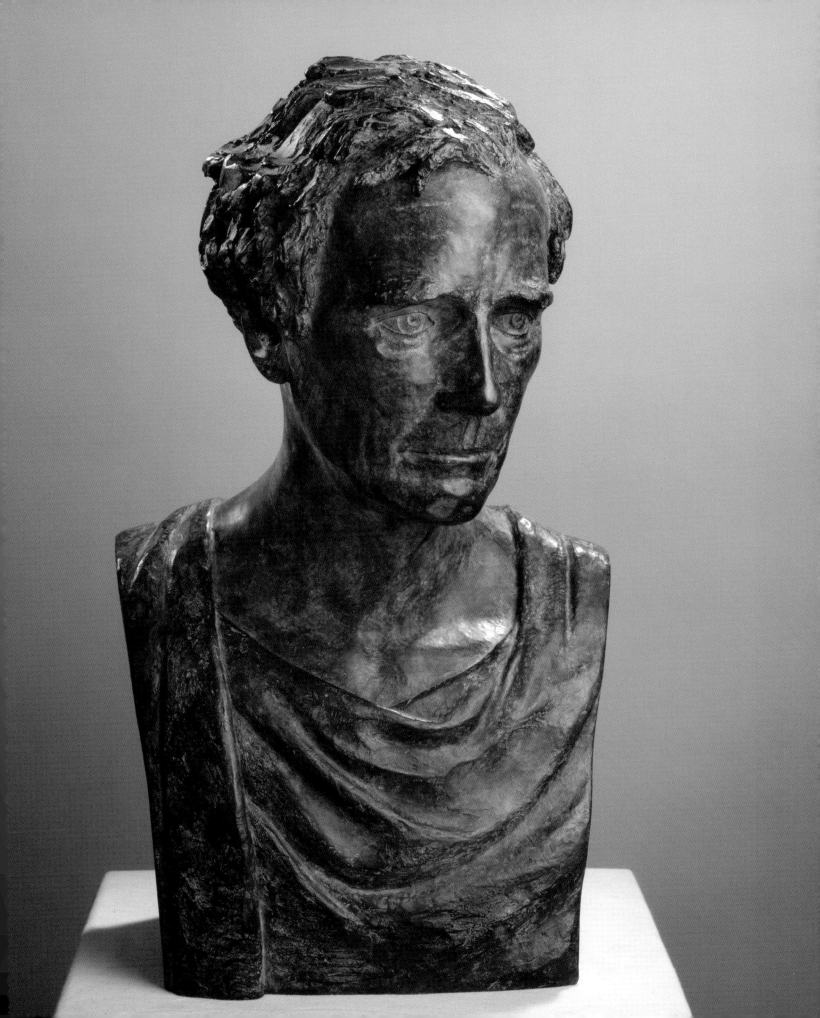

With Colquhoun, it is the intensity of the intellectual that comes through. So it wasn't difficult to find him in the form of a Roman senator, as someone like Seneca who appreciated the power of argument, but was also reconciled to the futility of words. That gave him a tragic look. He is draped in a garment that might be a toga. You can say that I was making up a fantasy about him, yet it was also a way of analysing his character by means of stereotypes, and who can say that I got him wrong?

In the meantime my husband, Robert Maxwell, had been appointed to be Dean of the School of Architecture at Princeton and I decided to accompany him to the United States. For the next ten years or so things were complicated by frequent trips across the Atlantic.

Alan Colquhoun, 1983,
Celia Scott, drawing, pencil on paper.

Opposite: Alan Colquhoun, 1983,
Celia Scott, preparatory drawing,
pencil and crayon on paper, 28 x 21 cm.

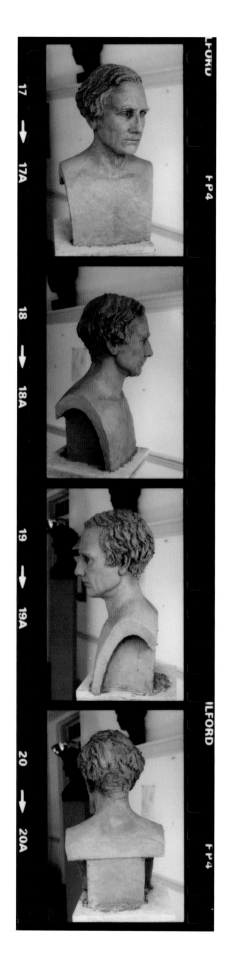

Left: Alan Colquhoun, clay, in process, 7 March 1983, Celia Scott.

Right: Alan Colquhoun, 1983, Celia Scott, drawing, pencil and crayon on paper, detail.

Opposite: Alan Colquhoun, 1983, Celia Scott, bronze, detail.

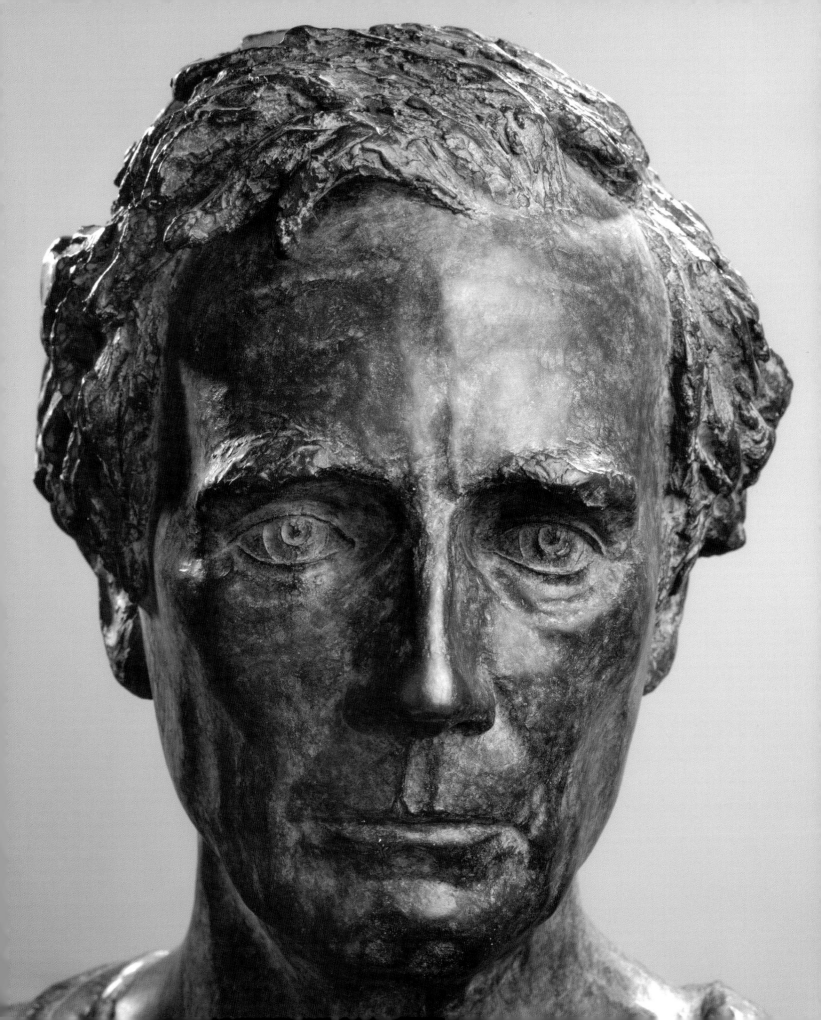

Michael Graves

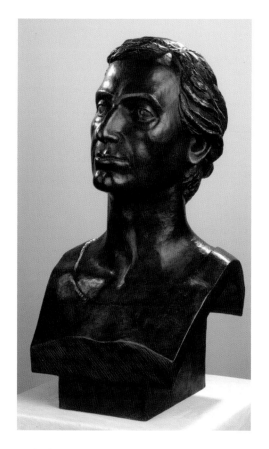

He normally wears rimless glasses, and they were a problem, I tried to evoke the sense of them by making slight indentations below the eyes in the shape of the glasses. There is no way you can put rimless glasses on a bronze bust.

In America, some architect friends were already lining up to be made into heroic figures. This took me aback, as that had not been my intention and anyway, wasn't portrait sculpture supposed to be dead? Up until now I had known the sitters quite well. With some ambivalence I took on Michael Graves, who was the well-known name teaching at the Princeton School. I had met him in London when he was over a few years before, but didn't know him as well as the earlier sitters. By this time I had taken over one of the summer porches in our big house, at least it gave me a space where I could play around with clay, and before long, by putting mirrors against some of the windows I gave direction to the light and turned the space into a passable studio.

Michael Graves, 1983,
Celia Scott, bronze, 55 x 32 x 24 cm,
private collection.

Opposite: Michael Graves, 1983,
Celia Scott, bronze, detail.

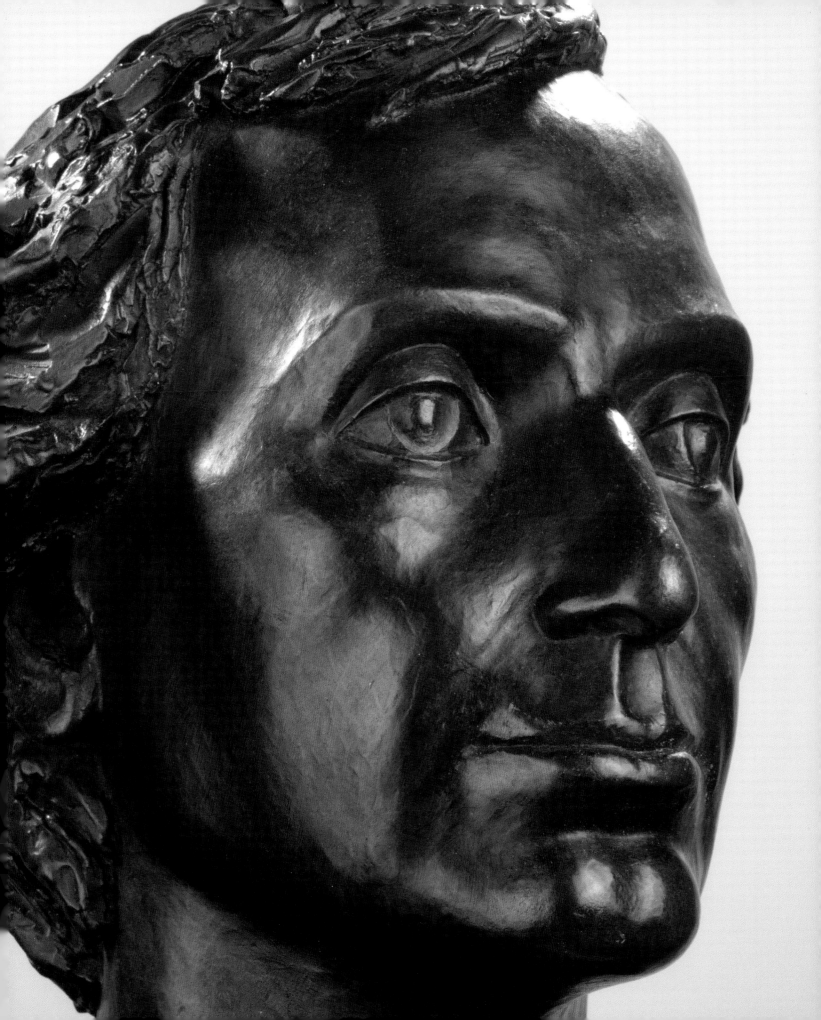

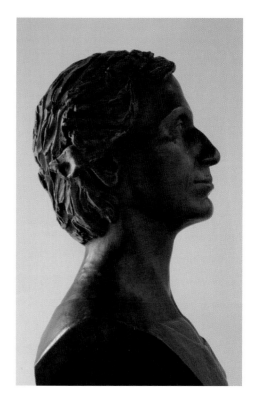

Michael Graves, 1983,
Celia Scott, bronze, 55 x 32 x 24 cm,
private collection.

Opposite: Michael Graves, clay,
in process, and sitting for Scott
on 9 November 1982, Celia Scott.

Michael Graves was not so easy, partly because he was the first American I had done, perhaps, but also because he was very tense. It helped when he made friends with our cat, a beautiful Russian Blue called Grishkin, and held her on his lap while sitting. I managed to do the head in relatively few sittings, and by now I could charge a basic artist's fee. Michael became famous for using the white-walled modern style, but he found the return to the imagery of classicism in post-modernism, congenial, and he has stayed with it.

I tried a similar bust form to the one I had used with Edward Jones. I even took a cue from the garlands of the Humana building in Portland and tried a scarf around his neck. But in the end I squared up the base and put the line of a simple garment around his neck and that seemed to work better. During the process with Graves, I learned to make more use of small maquettes to test the posture and form and completed the head with just half a dozen sittings in less than three months.

He normally wears rimless glasses, and they were a problem, I tried to evoke the sense of them by making slight indentations below his eyes in the shape of the glasses. There is no way you can put rimless glasses on a bronze bust.

Then we were due a long vacation, when we went back to Mall Studios, and there in the space of eight weeks I did, in quick succession, James Stirling and Eduardo Paolozzi.

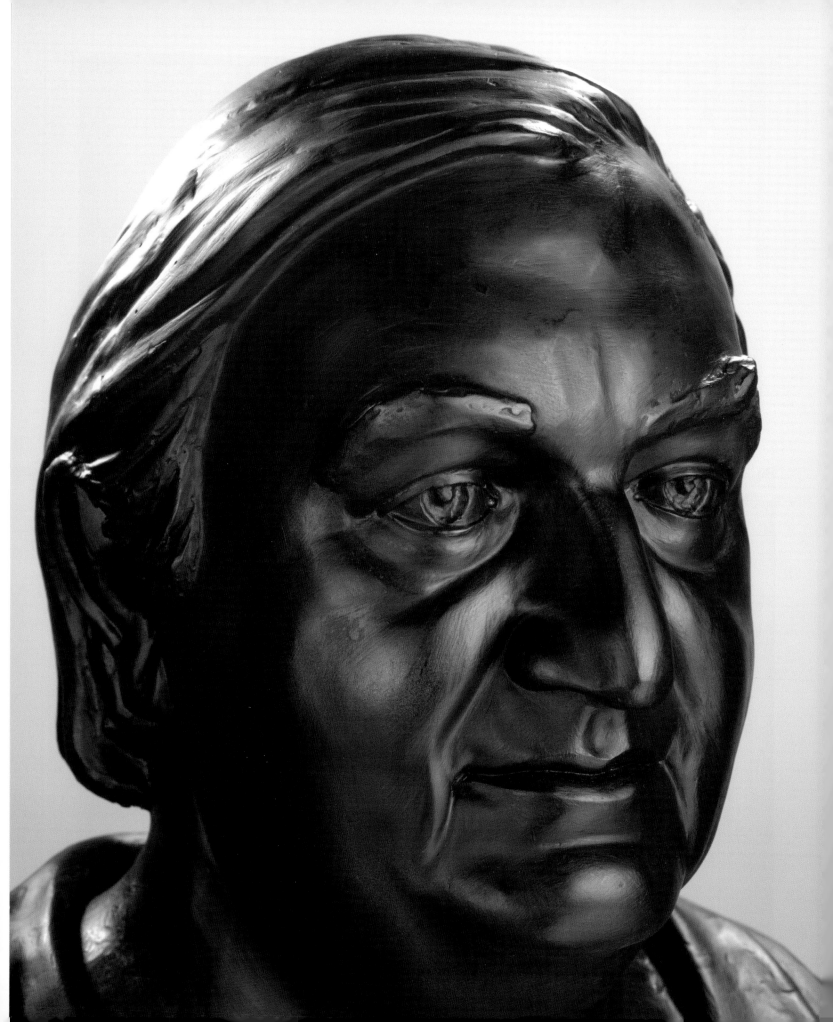

James Stirling

As it turned out, he was no problem as a sitter: all he wanted to do was to listen to music, so I only had to play our operas. We got through all of our Mozart, and when that ran out he brought his own tapes of Verdi.

Back in London that summer I asked James Stirling if he would sit for me. I was only there for eight weeks so it would have to be done fast. I had no doubts about wanting to do his head. I was in awe of him as he was such a great architect and a little afraid of him as he generally didn't say much. As it turned out, he was no problem as a sitter: all he wanted to do was to listen to music, so I only had to play our operas. We got through all of our Mozart, and when that ran out he brought his own tapes of Verdi. He also liked looking at books of sculpture, figurative sculpture of all periods, but especially the neoclassical. For such a large and abrupt man his visual perceptions seemed surprisingly delicate. He had made his name doing modern buildings, like the Engineering Building at Leicester, which he did with his partner, James Gowan. But more recently he was working on projects in Germany and had just completed the New State Gallery in Stuttgart. I saw in his work both neo-classical and vernacular strands and his character as complex, toughness mixed with gentleness. He came twice weekly for a month for sittings at Mall Studios, and in between I worked on the clay.

I thought of him as a sort of German baron or a bishop, someone who combined power with gentleness. The front edge of the bust is lightened with a curved lip, which came from the massive coved cornice he employed in the State Gallery at Stuttgart. While the bust was being cast he sent me a postcard of a bust of Napoleon by Chaudet on it, with the message "Don't you like the bags under his eyes?" on the reverse.

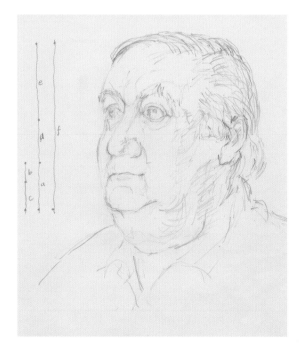

James Stirling, 18 July 1983,
Celia Scott, preparatory drawing, pencil
and crayon on paper, 28 x 20 cm.

Opposite: Bust of James Stirling in his house
on a cabinet designed by George Bullock.
photograph by Tim Imrie-Tate, the lithographs
are by Eduardo Paolozzi.

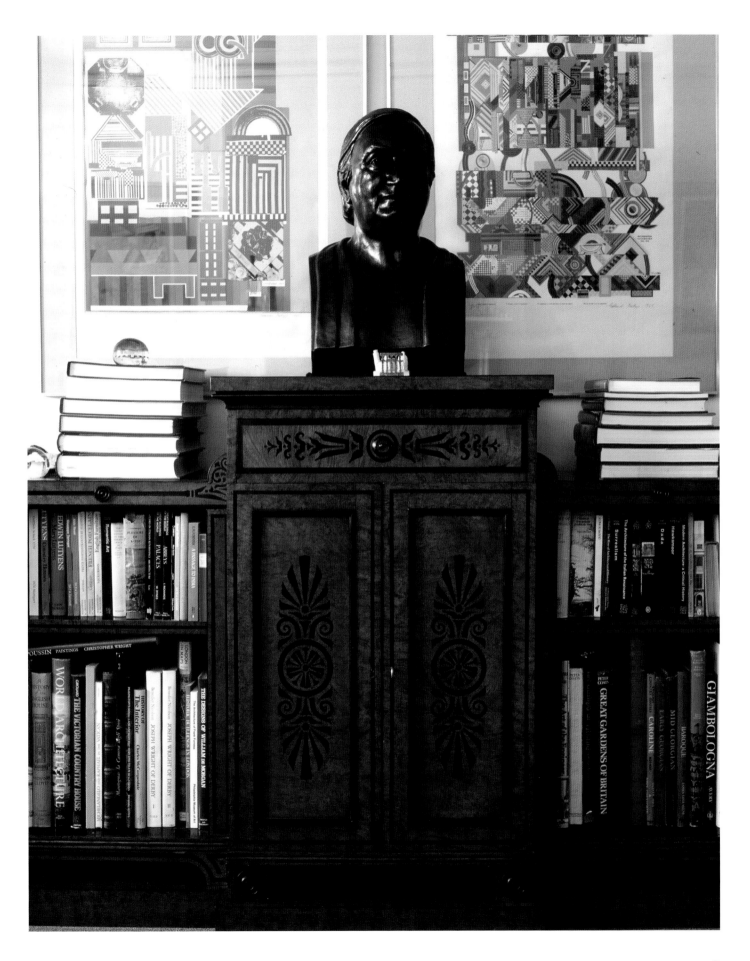

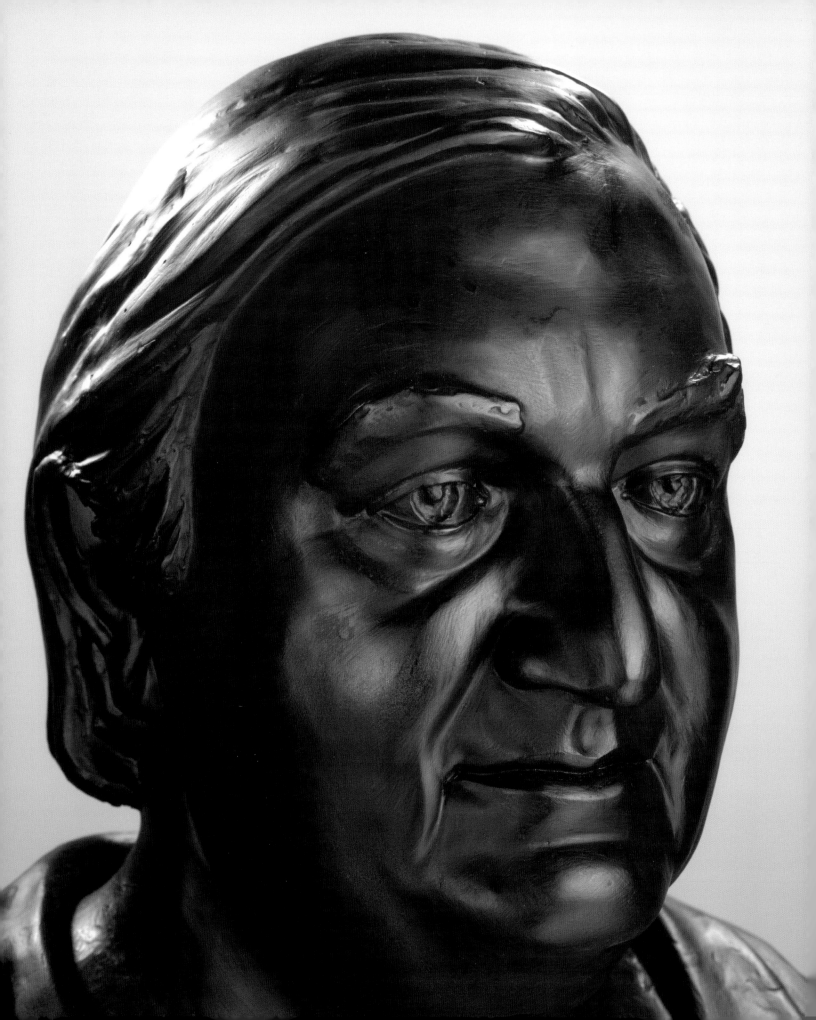

Opposite: James Stirling, 1983,
Celia Scott, bronze, detail.

Left: State Gallery, Stuttgart, coved
cornice to galleries, 1977–1983,
designed by Stirling Wilford.

Right: James Stirling, 1983, Celia Scott,
detail of base of James' bust.

Bottom: James Stirling, 1983, Celia
Scott, pencil drawing.

The Chaudet bust was finished in a black patina, so it seemed right to finish James' head in the same style. He displayed it in his living room on a piece of furniture, surrounded by Paolozzi prints on the walls. And now that he is dead and gone it still stands on the same piece of furniture in the room they have made at the National Trust for Scotland in Edinburgh, as a reproduction of his living room, with the same Biedermeier furniture all around. So the bust is doing its intended job, it does actually commemorate a famous man. And it represented him at the Royal Academy, as part of the Summer Show of 1986. His head is also on display in the Scottish National Portrait Gallery. The Scots and the Germans have been more favourable to him than the English.

More recently I was asked to design a commemorative plaque to James to be placed in the porch at Christ Church Spitalfields. Architects generally revere Nicholas Hawksmoor, and think of him as better than Wren. I made the plaque as a version of Stirling's design for the Clore Gallery, with a recessed pedimental form surmounted by a half-round lunette. The form evokes funereal things. The plaque was carved by Lois Anderson, it is installed in the right hand porch in rather poor light, but it shows up by the brightness of the stone and the simplicity of the form.

Left: Postcard of a bust of the Emperor Napoleon by Chaudet.

Right: Reverse side of postcard of bust of the Emperor Napoleon by Chaudet, sent by Stirling to Scott on 29 August 1983.

Opposite top: Clore Gallery (Tate Gallery) London, 1980–1986, designed by Stirling Wilford.

Opposite bottom: James Stirling Memorial Plaque, Christ Church Spitalfields, London, 2002, designed by Celia Scott, carved by Lois Anderson, Portland stone, 62 x 77 x 4 cm.

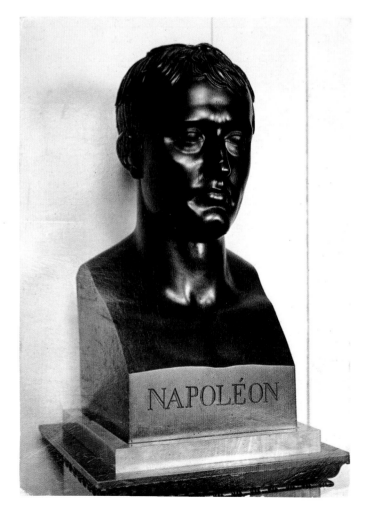

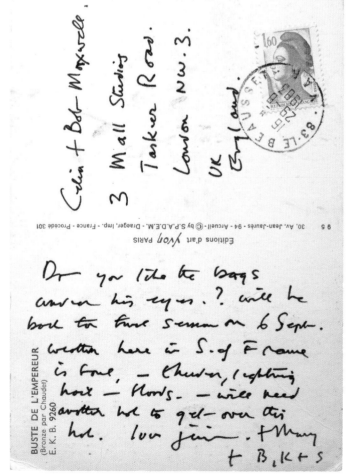

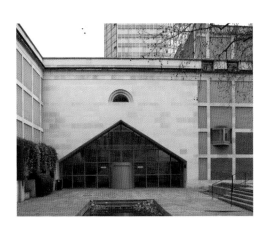

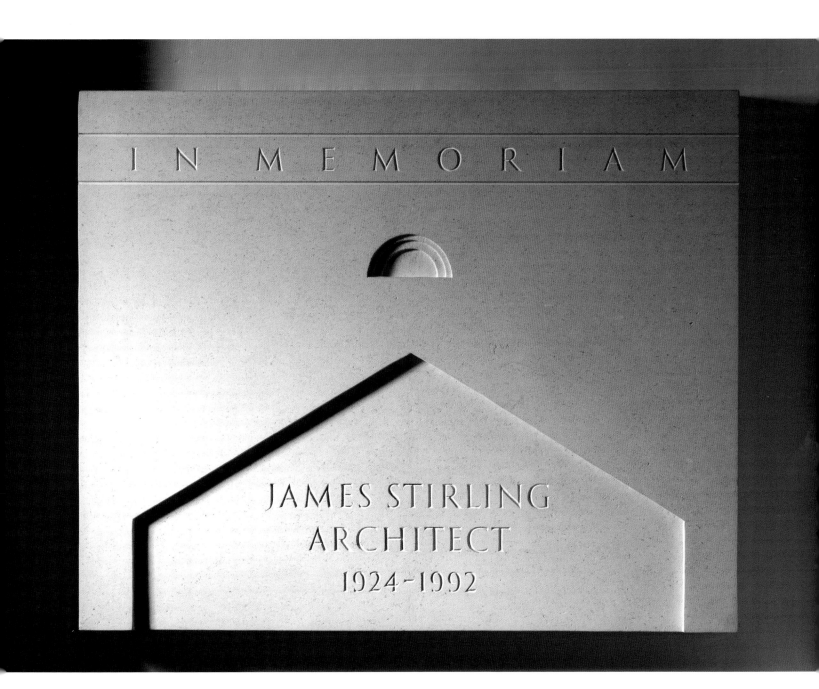

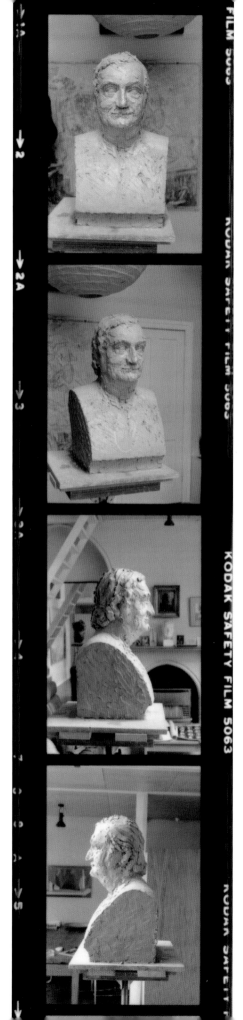

Left: James Stirling clay in process,
24 July 1983, Celia Scott.

Right: James Stirling on pedestal,
1991, Celia Scott, pencil drawing.

Opposite: James Stirling, 1983,
Celia Scott, bronze, 58 x 35 x 30 cm,
National Portrait Gallery,
Scotland and National Trust
of Scotland, Edinburgh.

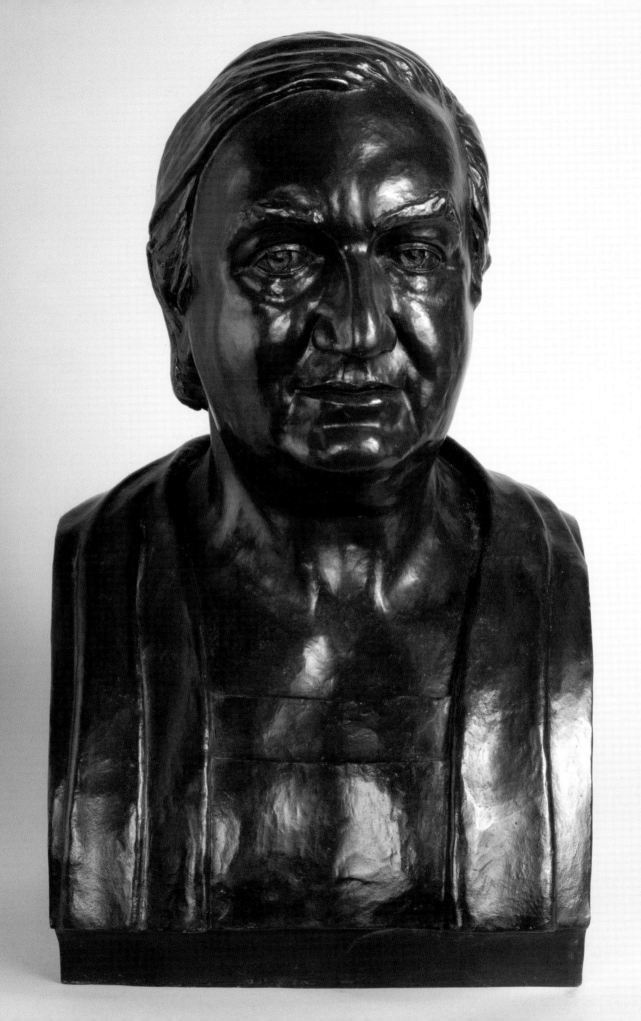

Eduardo Paolozzi

Eduardo Paolozzi, 1983, Celia Scott, bronze, 58 x 35 x 28 cm, a plaster cast version of this is in The Dean Centre, Edinburgh, Scotland.

Paolozzi came as a commission from Charles Jencks. He was doing up his London in a very symbolic way, with rooms dedicated to all the seasons and so on. On the ground floor he had a couple of fireplaces designed by Michael Graves, who had just been sitting for a bust by me in Princeton. Michael designed these fireplaces incorporating busts, which he suggested should be done by me. For the fireplace in the winter room, Vulcan (the smith and god of iron and fire) was to preside over the hearth. Charles' idea was for Eduardo to personify Vulcan, or Hephaestus, as the name is in Greek. It was arranged for me to meet Eduardo at the Royal Academy restaurant, and there I showed him my portfolio of heads. He immediately agreed to come for sittings.

This was quite a challenge for me. It was one thing to 'do' friends, people I knew well and with whom I was quite relaxed. Eduardo was a famous artist, a different proposition altogether. But I need not have worried, he was perfectly charming and quite relaxed on his side, which soon put me at ease. At first he stayed quite still, alarmingly still, attempting to be a good model. But people look wooden when they stay rigid, so I insisted he talk. This allows the muscles of the face to move, and when the head moves it allows me to capture the three-dimensional form with more ease.

Eduardo was intrigued by my interest in the neoclassical, and impressed by the fact that I had visited Canova's studio in Possagno. I still have his carefully compiled portfolio of Messerschmidt's work, which he gave me at that time. But he used the occasion to explain to me why what I was doing was quite impossible for a modern artist in this day and age: "You can't do whole figures today, everything has to be fragmented because we are living in a fragmented world." I knew the arguments already, along with abstraction it was current orthodoxy, and I wasn't particularly affected: it kept

> This was quite a challenge for me. It was one thing to 'do' friends, people I knew well and with whom I was quite relaxed. Eduardo was a famous artist, a different proposition altogether.

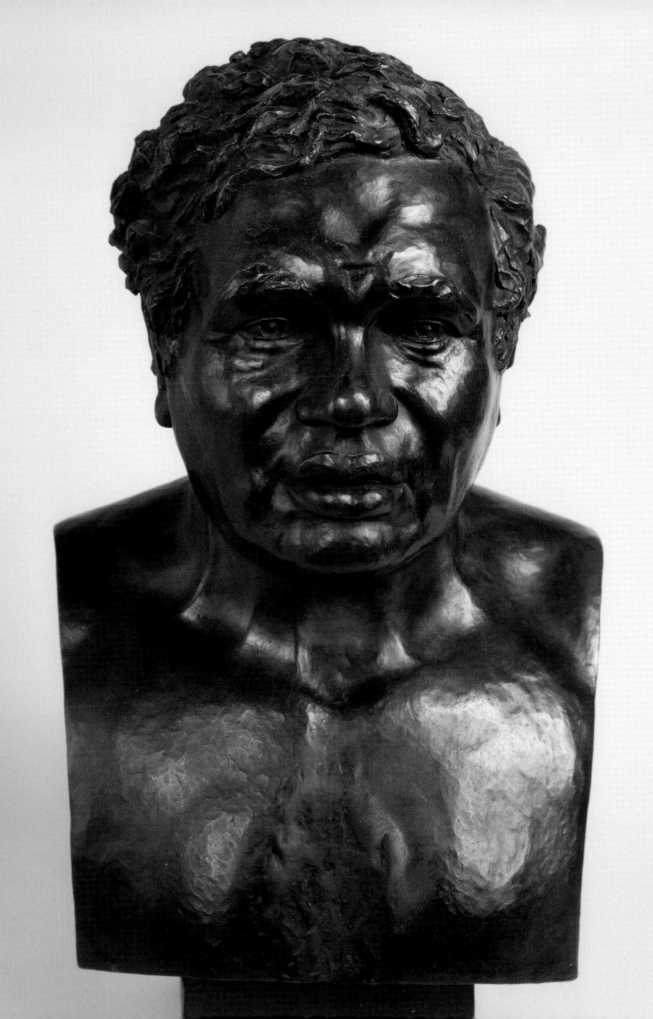

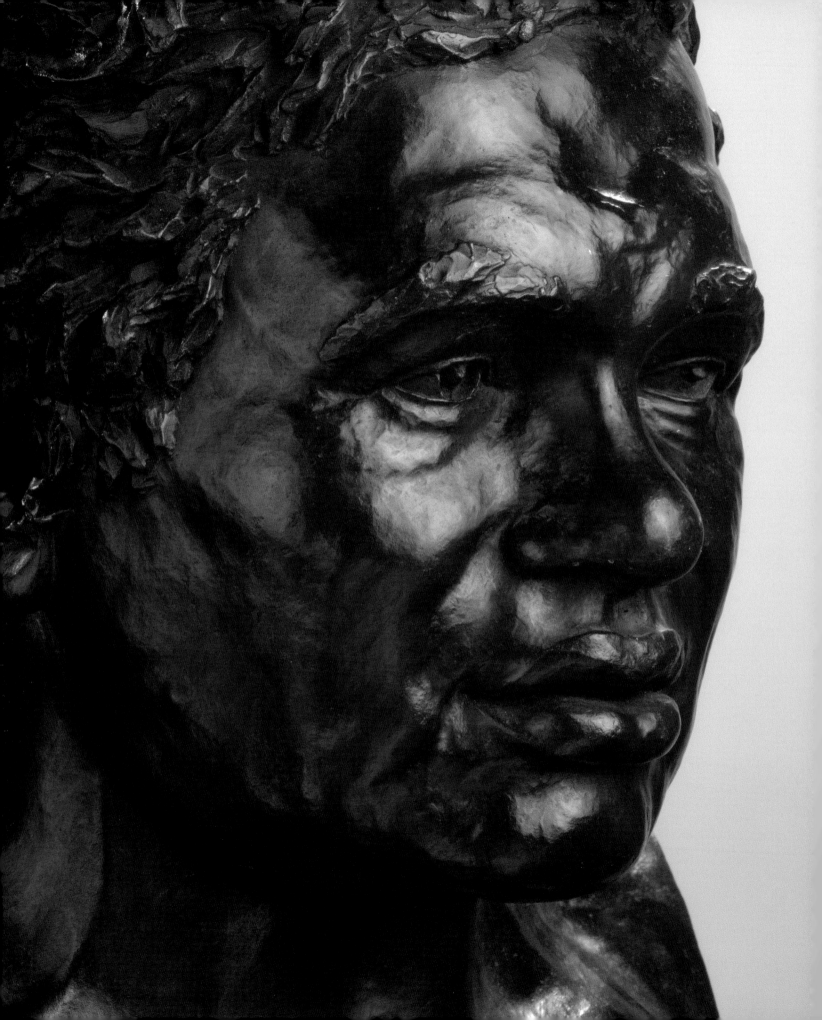

Opposite: Eduardo Paolozzi, 1983,
Celia Scott, bronze, detail.

Top: The comic book character,
The Incredible Hulk.

Bottom: Judas, detail, 1963, bronze,
Elisabeth Frink.

him happy and left me free to get on with it. I felt that the bust, being a fragment of the body, as well as incorporating its own support, could be both a traditional form and a modern object. Eduardo himself was later to do some more portraits, including a straightforward likeness of John Smith which is not fragmented or abstracted, a cast of which is now in the Scottish Parliament building. He also told me at that time that he didn't think one could do more than about one portrait sculpture in a year.

There wasn't much time, Charles had a deadline and I had to return to the United States, so I worked fast. Indeed, Eduardo was impressed, and complimented me on my speed. The seven sittings took place over a period of just as many weeks.

But of course there was also the challenge of his exceptional physique, which soon had me thinking about the Incredible Hulk as a type, partly because Eduardo had been interested in pop culture and comics, in the days when he first came on the London scene with the Smithsons. Also there was Elizabeth Frink's interpretation of the hulk: an apparently coarse type with some kind of vulnerability contained within. If you look at my bust quickly it seems an aggressive thing, but look more closely, in more detail, and you see the vulnerability. Then there was the traditional idea of a muscled, bearded figure in antiquity, as in the Lacoon, figures that I had become familiar with in my sessions at the Archaeology Department. So Eduardo set off a huge array of concerns, he was certainly a stimulating model.

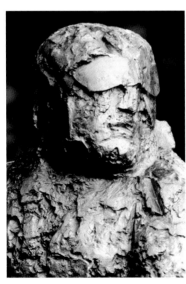

Left: Eduardo Paolozzi outside the
studio, 10 July 1983.

Middle left: Eduardo Paolozzi,
armature, 17 July 1983.

Middle right: Eduardo Paolozzi, clay in
process, 17 July 1983.

Right: Eduardo Paolozzi, clay in
process, 14 August 1983.

Opposite: Eduardo Paolozzi, clay in
process, 7 August 1983.

 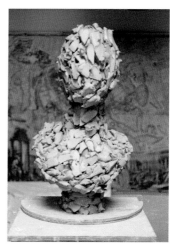

Eduardo became a friend. He gave me several plaster casts,
two heads, a pair of grasshoppers, a bas-relief of Blake, and so
on. He even gave me a closed book entitled Architecture, the
pages of which you could not turn, as it was made of solid wood.
At the end of the sittings he asked me for a plaster cast of my
likeness of him, asking for permission to cut it up. But every
summer after that, when I visited him in his studio in London,
there it stood, intact. Eventually, he gave it to the Dean Centre in
Scotland, where they have it in his reconstituted studio. During
the years immediately following our sittings he did a number of
self-portraits, using fragments of a cast of a head of himself that
looked remarkably similar to the one I gave him. One is even
titled *Hephaestus*.

Coming back to Vulcan, there was also the question of where the
bust would be displayed, it had a precise site on top of a column,
quite high up, and I had to think how it would look from below.

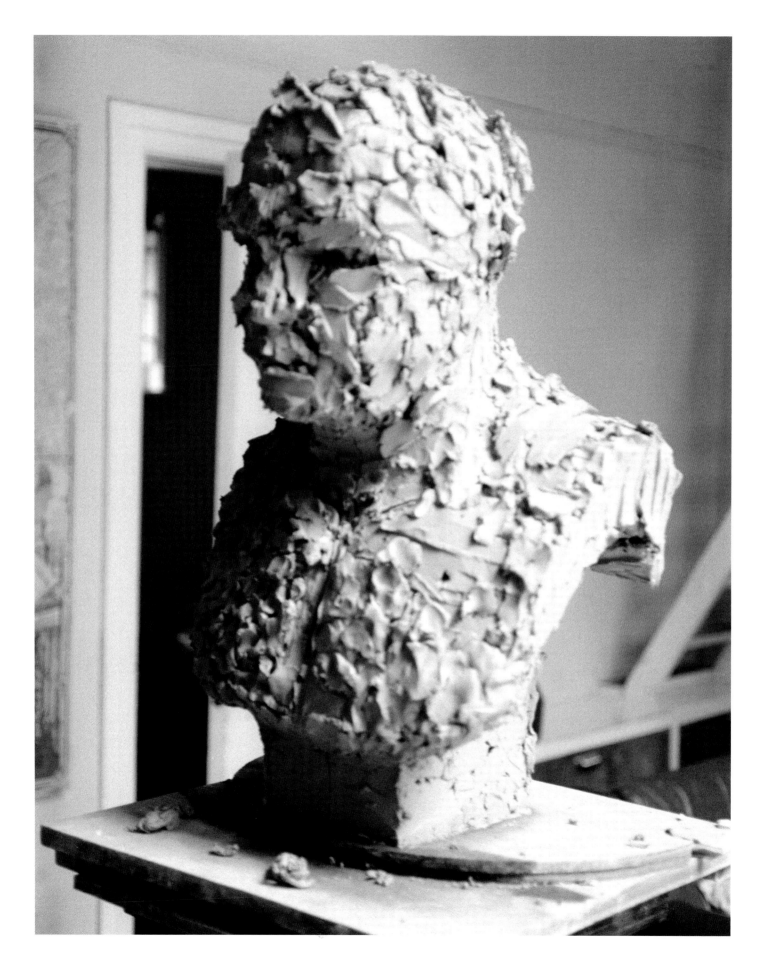

Opposite: Eduardo Paolozzi,
10 July 1983, Celia Scott, preparatory
drawing, pencil and crayon on paper,
28 x 21 cm.

Collection of FX Messerschmidt's
character heads.

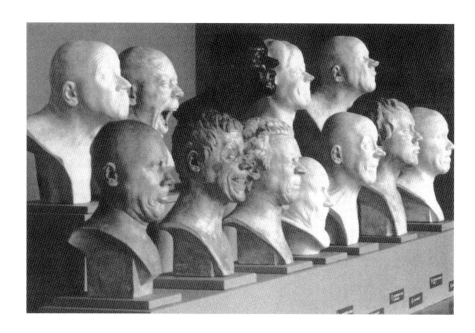

Because it stands so high up, it is made exactly one-tenth larger
than life. Also, it juts forward, so as not to seem too static.
But all these concerns came together in a surprisingly short
space of time, and I had to think fast.

My commission was from Charles Jencks, and he wanted an
antique bust of Vulcan, the god of iron and fire. This meant
adding the props that would make him into Vulcan. According
to Charles, Vulcan would have to be bearded with a hairy chest
and clad in a chiton.

I completed my likeness of Eduardo in clay, took it to the Art
Bronze Foundry who took a mould from the clay and made
a bronze and a plaster cast. I then added the beard and chiton,
though I now think it was much better without them. As I was
putting the finishing touches to this in the foundry, Elisabeth
Frink came in. She looked at it and said: "Ah, Eduardo! I sat
opposite him last night at the Chelsea Arts Club. That's him
alright!" So, in spite of the added beard, he was recognisable.
She also added in parting "I don't do portraits any more,
I can't afford to, they take far too long to do".

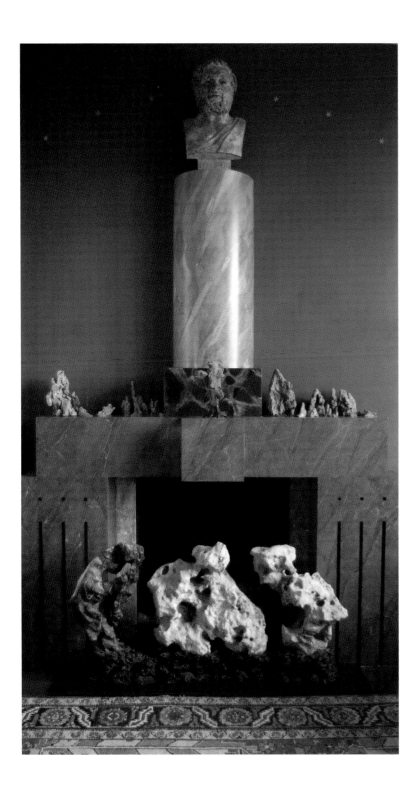

Opposite: Eduardo Paolozzi rubber mould, 1983, Celia Scott, mould taken from the clay model, a wax cast was taken from this mould to make the bronze.

Hephaestus, 1983, Celia Scott, a bronze bust of Hephaestus (or Vulcan) the god of iron and fire on a fireplace designed by Michael Graves in the winter room of Charles Jencks' house in London. Hephaestus is personified by Eduardo Paolozzi, with beard and chiton.

Peter Eisenman

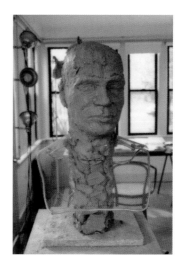

Peter Eisenman, preliminary
clay model with armature,
29 December 1983, Celia Scott.

Opposite: Peter Eisenman, 1990,
Celia Scott, iron with light graphite
finish, approximately 56 x 38 x 28 cm,
private collection.

Peter was well known for his ability to make an argument, so I thought of him as quite a Machiavellian character, sometimes full of gravity, sometimes behaving like a joker.

Back in Princeton, having done Michael Graves, it was only a matter of time before Peter Eisenman would want to be done as well. At this time, I was glad to for him to sit as I wanted to try working on an anti-classicist. He and Graves were sort of friends and rivals. Starting out with Graves, when they had both been Le Corbusier fans, he had moved away from classical modernists like Giuseppi Terragni towards de-centering and deconstruction. He had just undertaken a highly visible collaboration with Jacques Derrida. I had met him in London and New York, and thought highly of the Institute of Architecture and Urban Studies he had set up. He was coming to Princeton frequently, because he was interested in becoming Dean of Architecture after Bob, so it wasn't difficult to have sittings, and indeed it turned out he liked the process. He even rented a house in Princeton. At one stage during the sittings he asked for a pair of scissors and proceeded to cut up a piece of paper upon which he had written a text by hand. He then began to re-assemble arbitrarily it in the manner of the Da-Da-ists, so he said. The problem of doing his head wasn't one of getting started, but of finishing it off. Finishing his head took forever, not only because Peter trying to influence the outcome, but also because of my transatlantic situation. Regardless, I had no doubt how I should approach the task.

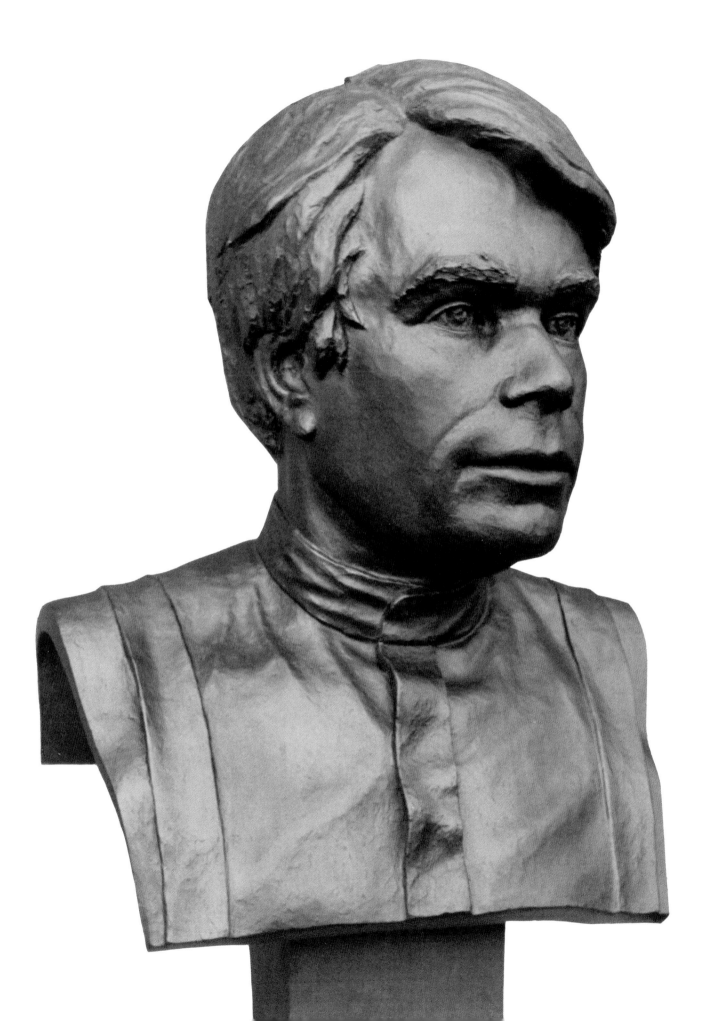

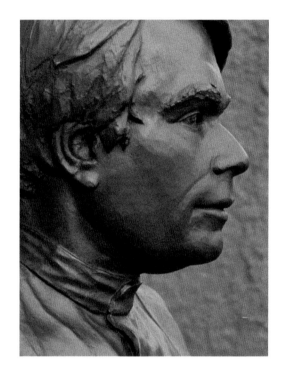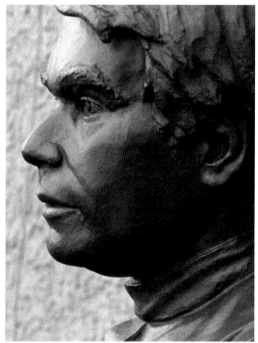

Opposite left: Peter Eisenman, right side, 1990, Celia Scott, iron.

Opposite right: Peter Eisenman, left side, 1990, Celia Scott, iron.

Peter Eisenman on pedestal, final version, 1991, Celia Scott, pencil drawing showing pedestal with diagonal slot.

Peter was well known for his ability to make an argument, so I thought of him as quite a Machiavellian character, sometimes full of gravity, sometimes behaving like a joker. I saw him as something of a wild card. I tried to bring this out by varying the character of his face so that from different viewpoints you saw these conflicting aspects. Also, he is wearing the collarless shirt of a priest, along with the braces of a journalist. Finally, after working on the clay and on the wax, after several years and numerous sittings, it was cast, in 1987. Following his tough character as well as his name, which means 'iron man', it is cast in iron, not bronze. This also seemed to go with making the form of the shoulders thin, which contradicts the solidity of the normal bust. The cast is on loan to a private collector in the United States. Peter didn't pay the artist's fee, there is always the possibility that the sitter will not take to the likeness I have made, so a let-out clause gives the option for him not to take it, and this allows me to do it as I wish.

By now my reputation as a maker of likenesses was well established, and the circle was widening, but I began to have more general thoughts about what it all added up to. I was exhausted from having done four heads over the past year. For one thing, I then knew that Eduardo had been right and that I couldn't do more than one or (at the most) two heads a year. What I had blundered into in naivity, I was now more circumspect and cautious about. I also realised that that for some reason the heads I had done were mostly male. Women don't come forward to ask for their bust, and there were not so many women architects in the public eye. Surely it was time to consider doing a woman?

Françoise Choay

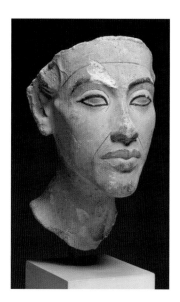

Egyptian Head, Portrait
of King Akhenaten, eighteenth
dynasty, plaster.

Opposite: Françoise Choay, 1994,
Celia Scott, painted plaster, detail.

I was looking for something basic
in the face structure, and her high
cheek bones suggested something
Egyptian, and the strength of women
in a matriarchal society.

There was one obvious candidate: the historian Françoise Choay,
another friend of my husband, an eminent urban historian, and
interested in modern architecture. We frequently visited her in
Paris. She is a very attractive, rather petite, Frenchwoman. She
wasn't sure about the proposition, and had to be persuaded to
sit for me. For one thing, she didn't enjoy having to keep still,
and assumed she would have to. I tried to reassure her. She
stayed with us briefly while teaching at Princeton, so I seized the
opportunity, though I only managed to catch her for six very short
sittings, of sometimes only a few minutes.

She was a scholar of both medieval and modern times, and this
seemed to give her a role of mother of the arts, the medieval
men all being away at war. The problem was how to convey this
perspective when she was also a chic Parisian and her hair style
conveyed contemporary sophistication. I started by leaving
out the hair entirely. I was looking for something basic in the
face structure, and her high cheek bones suggested something
Egyptian, and the strength of women in a matriarchal society.
Nevertheless in the first version, this interpretation came over
as stiff and lacking in life. So I started again from scratch, and
remodelled it very quickly. All this took time and though the head
had been started in 1984, it was not completed until 1986.

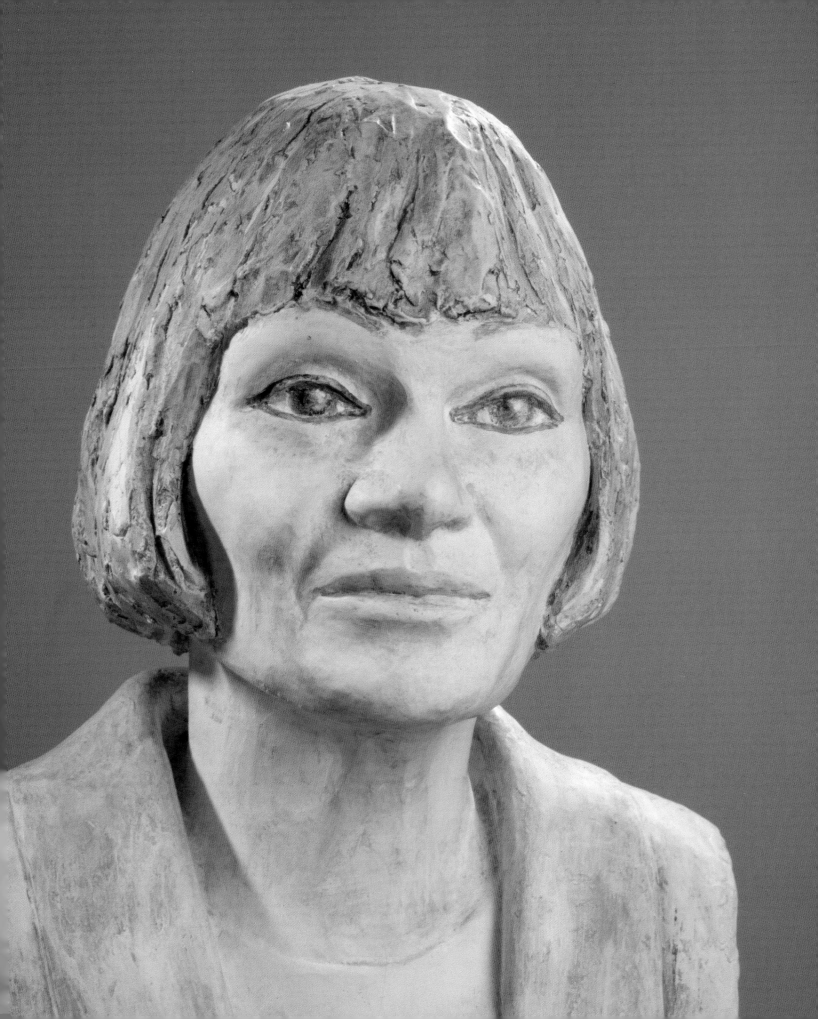

Françoise Choay, 1986,
Celia Scott, bronze, approximately
45 x 30 x 23 cm.

Opposite top: Bust of Battista Sforza,
Duchess of Urbino, c 1473, Francesco
Laurana, marble.

Opposite bottom: Scott's Studio
in 2000, left to right, heads of
Françoise Choay, TS Eliot, Rita Wolff
and Richard Meier.

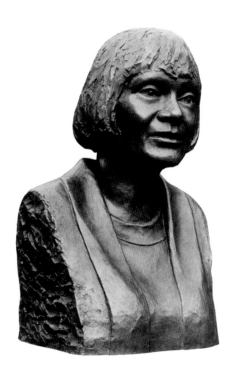

One thing that I saw clearly from modelling Françoise was that
the traditional bust form would have to be abandoned. It would
look altogether wrong, it had to be gentler, more naturalistic.
So, her head could be joined to her body, but would have to be
cut off some way below the shoulders, and be clad in a garment.
I soon found that her hair was the key to a unity of form—the
bust part echoes her hair falling around her face.

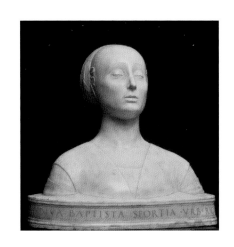

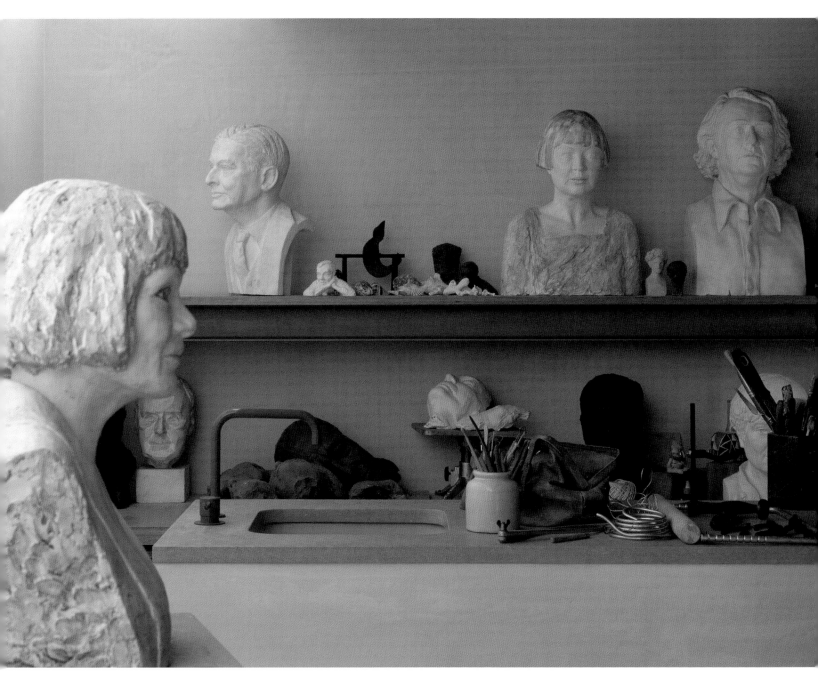

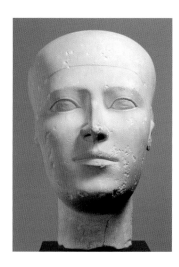

Left: Egyptian head, fourth dynasty, limestone, 28 cm high.

Right: Françoise Choay working clay in process, 14 March 1984, Celia Scott.

Opposite: Françoise Choay, 21 June 1984, Celia Scott, early version in unfired wet clay.

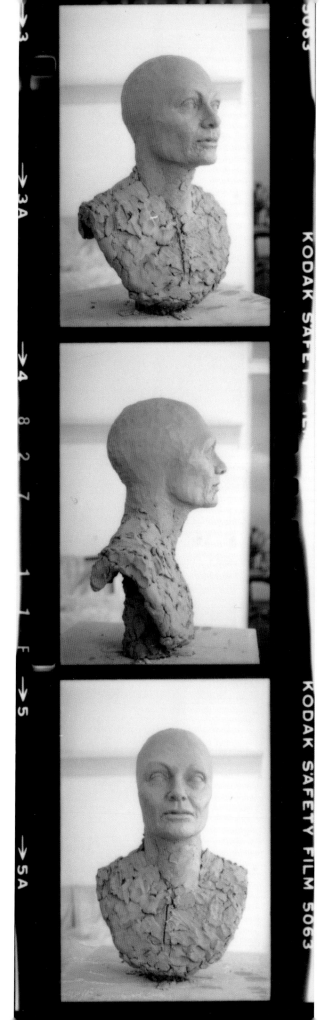

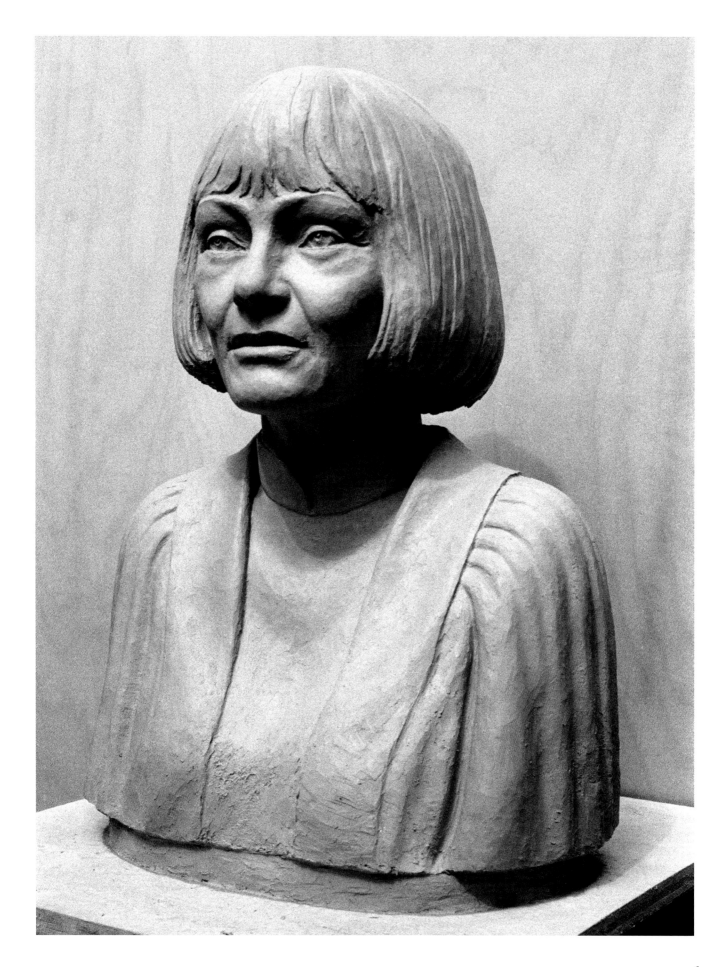

Richard Meier

It was James Stirling who was keen for me to do a head of Richard Meier. I think he may even have persuaded Richard to sit. I was interested in doing his head, as he was a high modernist, and this might give me new problems of portrayal. But Richard was a busy man, already highly successful, and was about to start work on the Getty Museum. At first he could not come to Princeton for sittings. He was going through a divorce at the time and I saw a sadness in his eyes. So I had to model him in his pristine apartment in New York, and was allocated a space in the gallery of his home.

Richard had a good head, no question, but I didn't know how to finish it off. It was inhibiting working in those conditions. So I took the head back to Princeton, and worked at it in my studio there. By this time he had become interested himself, and was now able to come down for sittings, which happened a number of times. But all this slowed the process down and it took in all three years to complete. As he is a modernist, I depicted him wearing an open-necked shirt, as if ready for tennis, giving him an open air look. His hairstyle leant itself readily to a more romantic interpretation of the architect-genius. At that time all his buildings were white so I considered giving the bronze a white patina. I finally decided that it should have a patina closer to the natural colour of bronze before it weathers. When I came back later to borrow the head for an exhibition I found it placed on a rough wood pedestal in the breakfast room, where the children would pat it before going off to school.

Around this time Peter Eisenman tried to persuade me to do a bust of Philip Johnson, and he was quite open to it. But, he also would have no spare time, and would have required me to come to his place, in this case, his office. There he offered me the choice of the entrance foyer or the xerox room. I did go and have a photo session with him, including shots taken without his glasses, which he never normally permitted. I have them still. However, with my experience of working with Richard Meier, I didn't at all relish being displayed in his office, so I had no difficulty in turning down both places, and the idea vanished. And with that went the problem of his spectacles, so much part of his appearance, which I would otherwise have had to come to terms with.

As he is a modernist, I depicted him wearing an open-necked shirt, as if ready for tennis, giving him an open air look.

Richard Meier, 1987,
Celia Scott, bronze, 59 x 32 x 28 cm,
private collection.

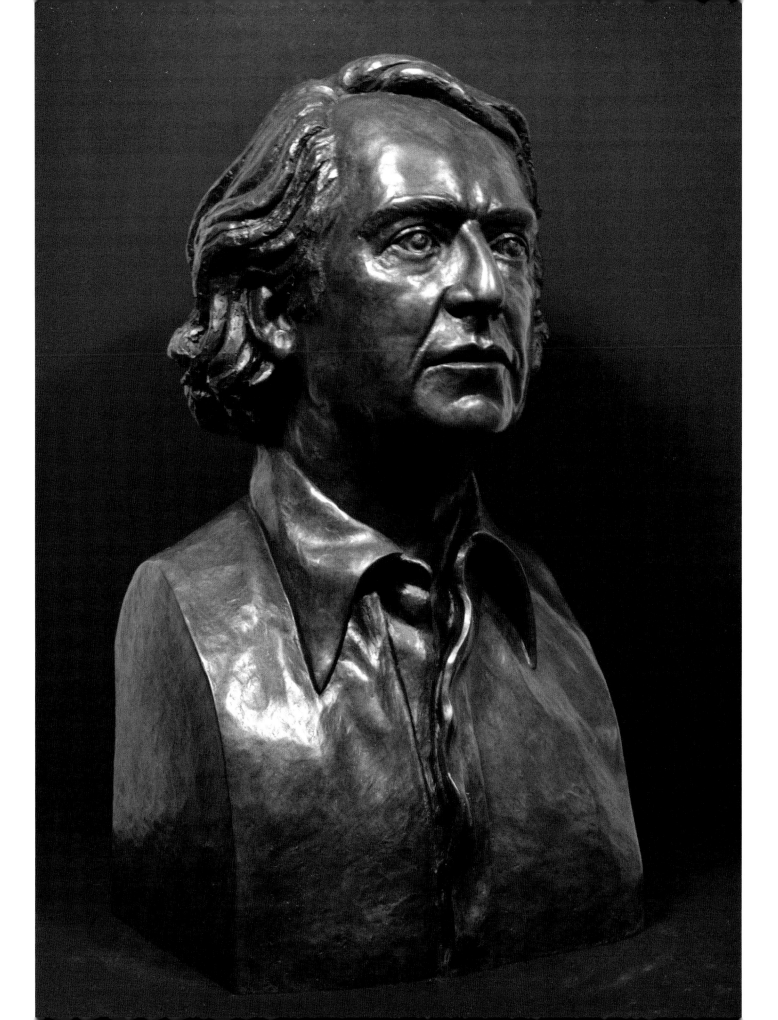

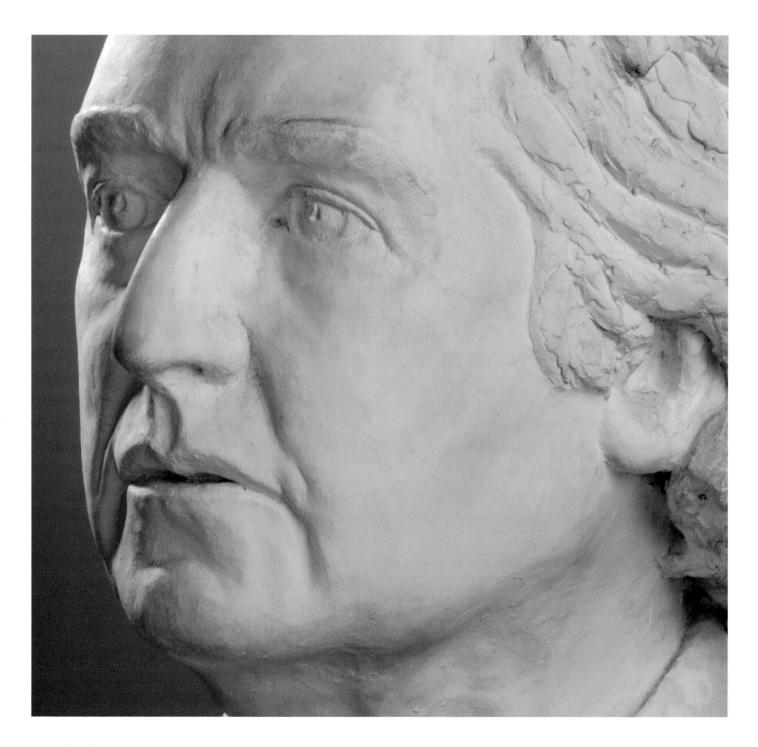

Rita Wolff

Dream, 1996, Rita Wolff, oil on canvas, 76 x 72 cm.

Opposite: Rita Wolff, 1991, Celia Scott, painted plaster, 50 x 40 x 23 cm, private collection.

Plaster is not generally considered a suitable material for finished pieces because of its fragility, but Eduardo Paolozzi, taking his cue from Rodin, has exhibited plaster pieces. I decided to make it in plaster.

I was still thinking about the general problem, for me, which lay in the fact that most of the heads I had done were of men. To begin with, I didn't know many women in the public realm, and those I did hadn't come forward to sit. So I conceived the idea of doing a head of my friend Rita.

Rita Wolff is a painter of visionary architecture, imaginary landscapes and dreams. Her paintings sometimes have the quality of Italian primitives. Rita has an interesting head, so I approached her and asked if she would sit for me. She agreed, but did not want her head cast in bronze. We both thought that bronze would be too monumental, hard and masculine.

I was thinking about Canova, who uses white marble so freely that it's almost like plaster. I had visited Canova's studio in Italy, and was amazed at the scope of his work. He tends to arrive at a sort of smooth classical effect, very idealised. But in his studio were some small clay maquettes which were much more expressive, almost expressionistic. I think he often started with the maquette, then used his assistants to turn it into a larger work in marble, using a quite scientific method of defining the form by dots, then finishing it off himself. There were several of these plaster casts in Possagno.

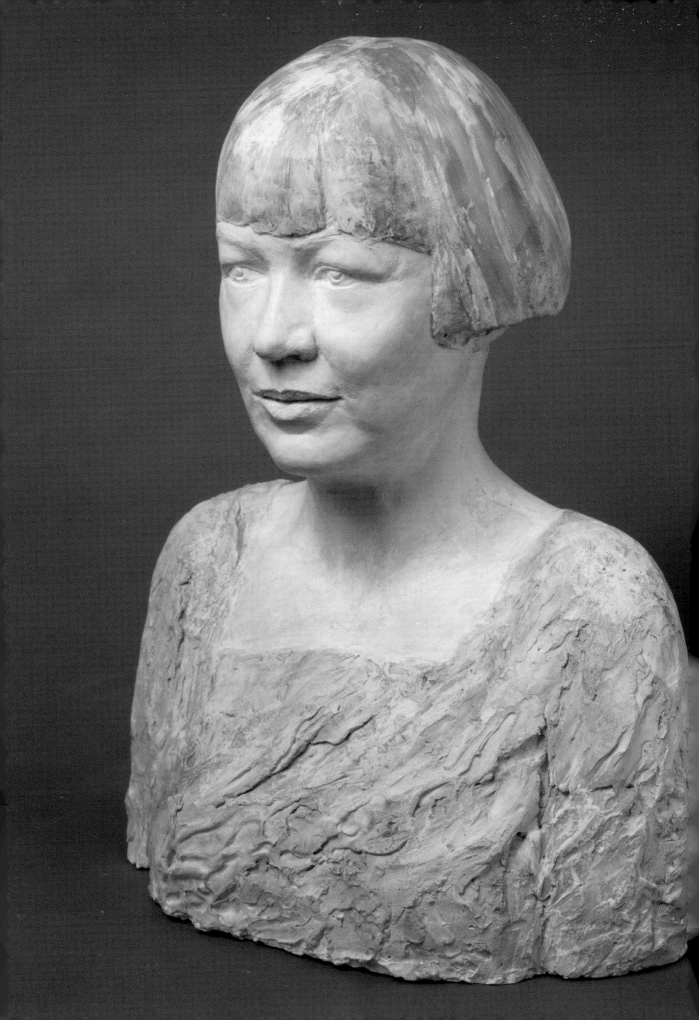

Rita Wolff, 1984, preparatory drawing,
pencil and crayon on paper,
28 x 21cm.

Opposite: Rita Wolff, 1988, plaster,
50 x 38 x 23 cm. Scott worked on
the head in Mary Stirling's garden,
during the summer of 1988.

Plaster is not generally considered a suitable material for
finished pieces because of its fragility, but Eduardo Paolozzi,
taking his cue from Rodin, has exhibited plaster pieces.
I decided to make it in plaster.

Rita was only the second woman sitter I had and I again
looked to the matriarchal culture of ancient Egypt for
inspiration: at painted Egyptian mummies, and at the
Fayum painted portraits, done by anonymous painters
and depicting peoplebefore they died, in order that the
gods might recognise the correct spirit in the afterlife.

Raw plaster is bright white and can kill form, so I wanted
to colour the plaster. After all, Rita is a painter. I did not
want to apply a thick coat of paint to the surface in the way
of the ancient Egyptians, but to use the more subtle colours
of the painter Piero della Fransesca, whose work some of
Rita's paintings have evoked. Piero della Francesca did
frescoes, where tempera paint is applied to the plaster
while it is wet, so that the paint becomes integral with it.
In Rita's case, I applied thin washes of watercolour freely
to the damp plaster.

This head took several years to complete, as Rita was in London
and I was based in America. I carried the plaster across the
Atlantic in my luggage twice so that I could complete it, finding
myself alternating between carving the plaster and modelling
it. Later, I've sometimes used this technique in clay. At the
back of my mind were Adrian Stokes' ideas about carving and
modelling. Stokes thought that carving made use of the intrinsic
qualities of the way a material like marble reflected light and that
modelling was different, as it did not need not take account of
the material. A modelled form could be cast into any material.

At first it became a traditional bust with cut off shoulders,
then it became more naturalistic as the top part of the body
continues and is terminated at a certain point. It began to
come off the pedestal. The worked plaster became textured,
tactile, and coloured, and I felt that these aspects expressed
the feminine.

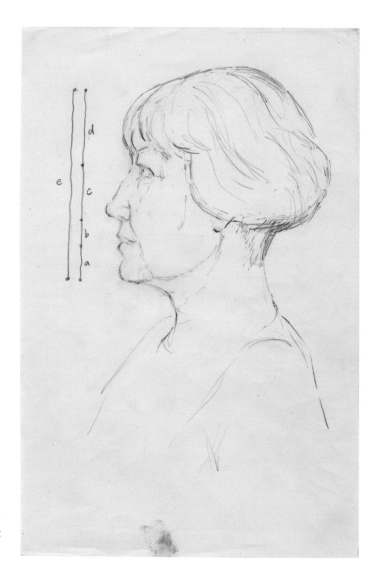

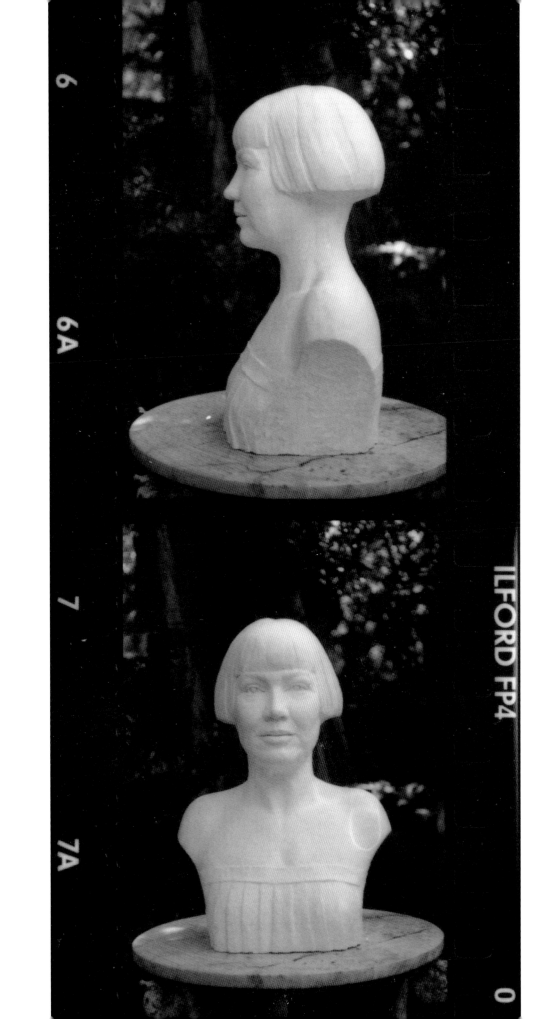

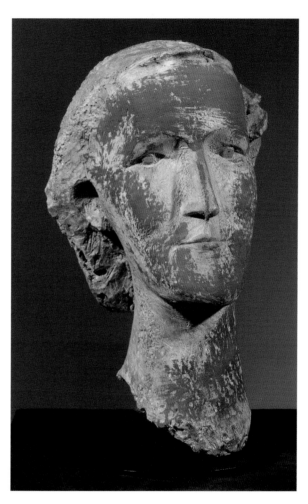

Left: Portrait of Madame
Etienne Grandjean, 1945,
Marino Marini, colored gesso,
35 cm high.

Right: Ideal Head of a Woman, 1817,
Antonio Canova, marble.

Opposite: Rita Wolff, 1991, Celia Scott,
painted plaster, detail.

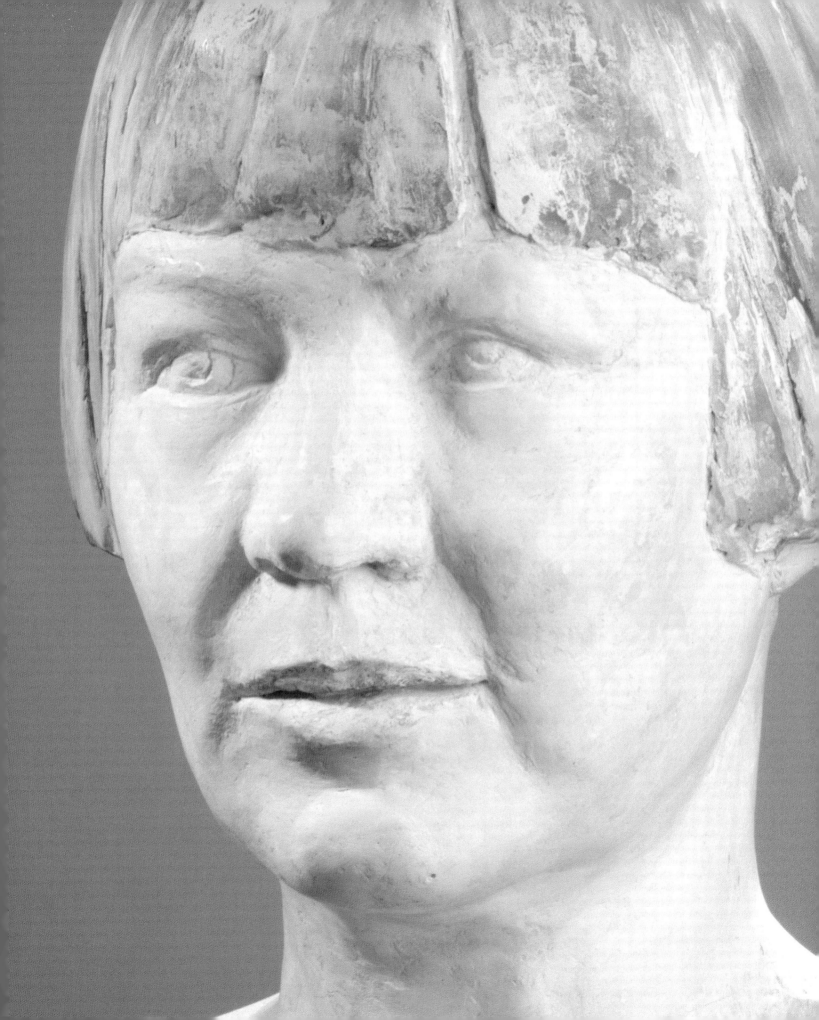

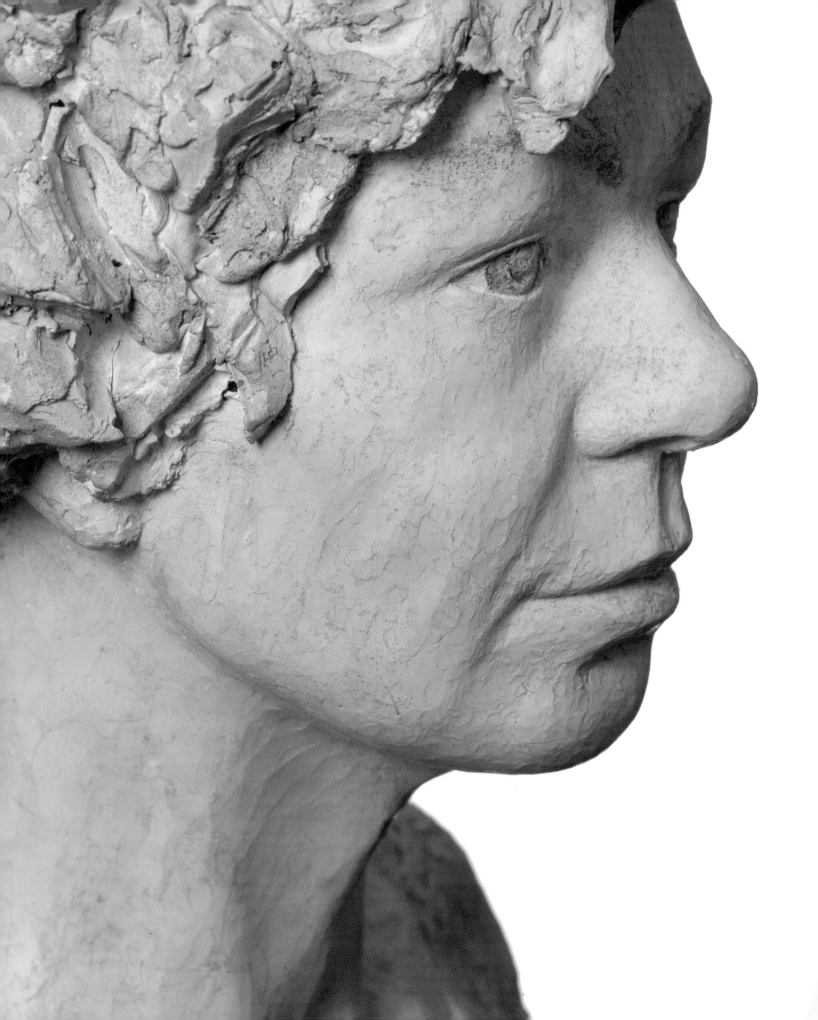

Self Portrait

It's quite intimidating to turn your method on
yourself, when you are normally trying to see
behind the surface and enter the psychological
level. An element of self-analysis is unavoidable.

Back in the United States, and still thinking about women sitters, I thought of
doing a self-portrait. Why not? I realised that my own head was endlessly available,
there was no problem with sittings. I did a bust, in plaster, and later on I painted it
as I had done with Rita's. It's quite intimidating to turn your method on yourself,
when you are normally trying to see behind the surface and enter the psychological
level. An element of self-analysis is unavoidable.

I didn't get it cast in bronze, so it has a more immediate quality, whereas bronze
tends to put you at a distance. I also experimented with a number of bas-reliefs.
This coincided with a period when I was working as an architect for a number of
New York practices, so I got into other things, and didn't spend so much time
thinking about heads.

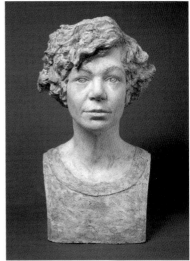

Opposite: Self Portrait, 1990,
Celia Scott, hydrocal, detail.

Left: Mask of a Woman with
Inlaid Glass Eyes and Eyelids,
a mummy portrait from
Roman Egypt.

Right: Self Portrait, 1990,
Celia Scott, painted hydrocal,
48 x 28 x 30 cm, artist's collection.

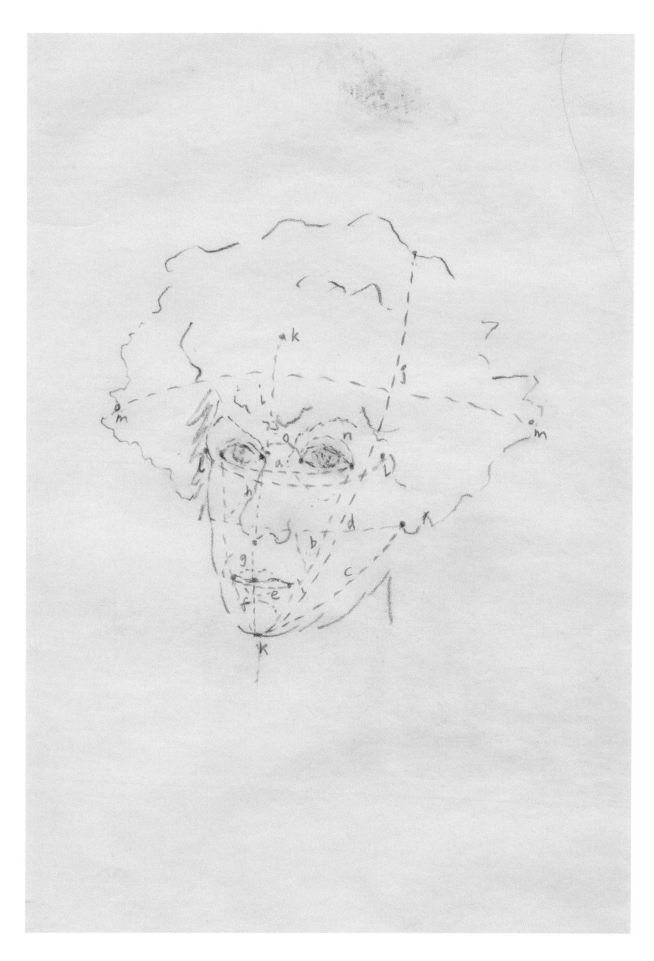

Opposite: Self Portrait, preparatory
drawing, 1989, Celia Scott, pencil and
crayon on paper, 28 x 21 cm.

Self Portrait, 1990, Celia Scott,
painted hydrocal, 48 x 28 x 30 cm.

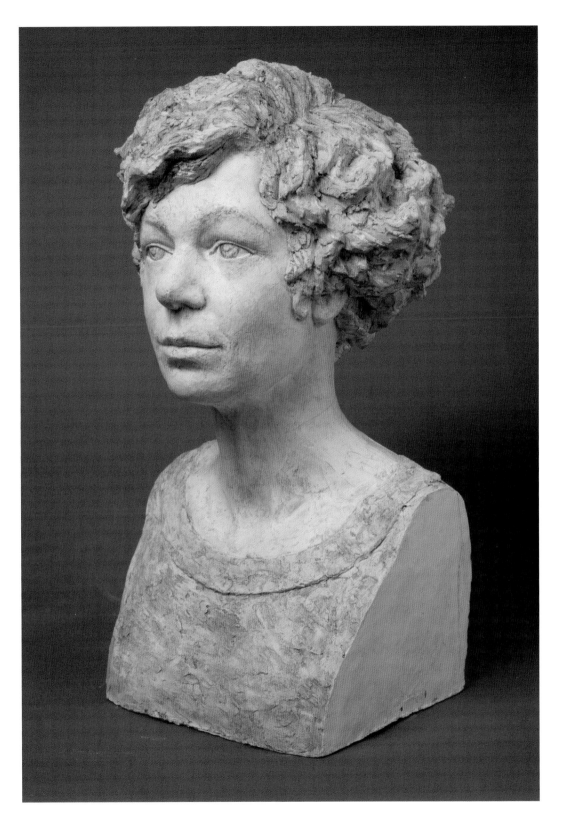

Figure Heads

In 1991, John Nichols invited me to make a show of the heads in his not-for-profit gallery in Grand Street SoHo. I was not sure whether to accept, since, with the exception of my self-portrait, most of the heads had been all but completed several years before. The immediate problem would be how to display the work. When I began to think about the task, new possibilities came to light. The bust form had been thought of as a way of complementing the characters of the heads. If I put each one on a pedestal, the pedestals could be related in some similar way, more abstract. The face, the bust, the pedestal, could all work together, at different degrees of abstraction.

So I designed a set of bases, to be made cheaply in plywood, and then painted. The bases were of different heights and each was to a slightly different design, related in some way to the head it supported. Leon's had a traditional herm form, and Peter Eisenman's started off as a framed grid (one of the many things he had been talking about in the sittings was Jewish number theory) but ended up as a solid squared shaft with a diagonal slot, a reference to his design of House VI. If I added up all the heads I had done, they came to twelve. So thinking of them as arranged in a row, I had 12 heads in a row of 12, or two rows of six, or three rows of four or four rows of three.

The immediate problem would be how to display the work. When I began to think about the task, new possibilities came to light.

Opposite: Celia Scott in her studio, 1991, clockwise from left, Head of John Miller, Self Portrait, James Stirling, Celia Scott, Rita Wolff and Edward Jones.

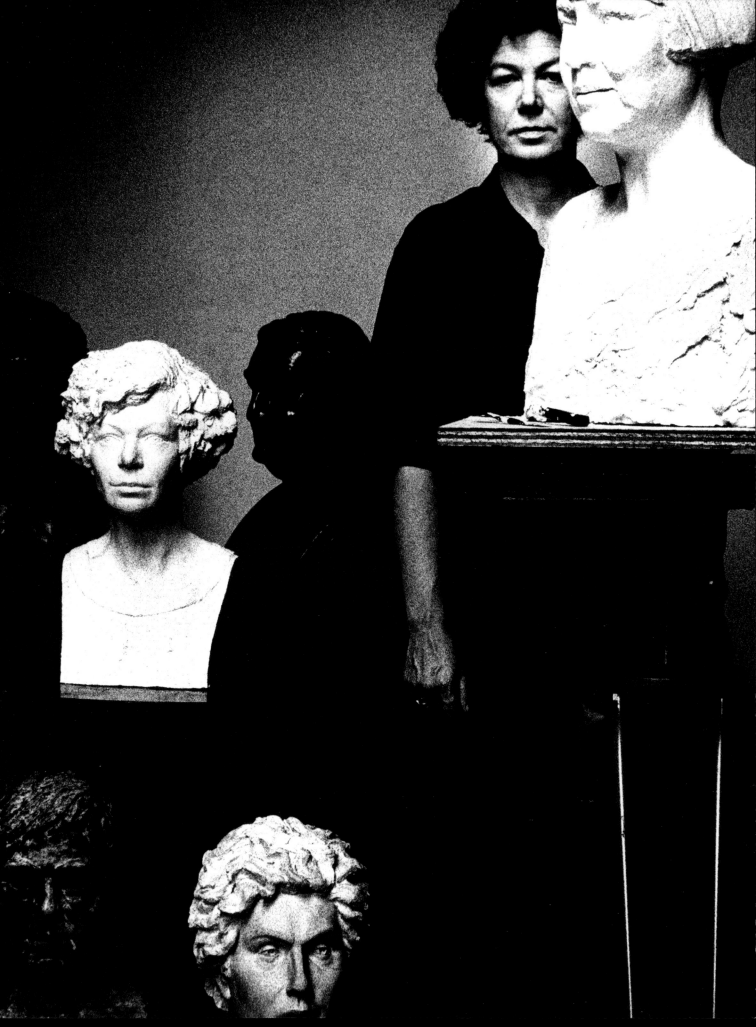

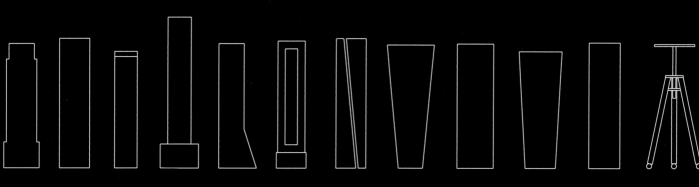

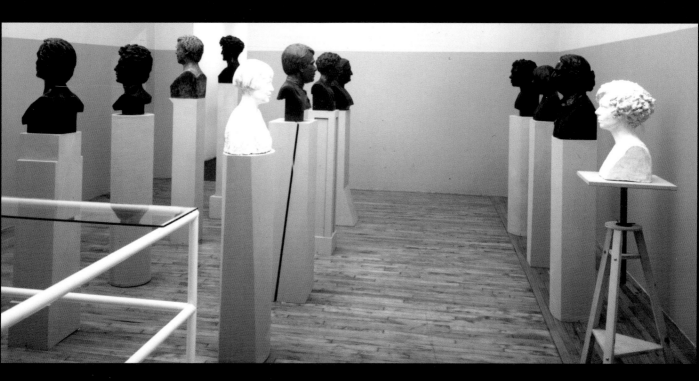

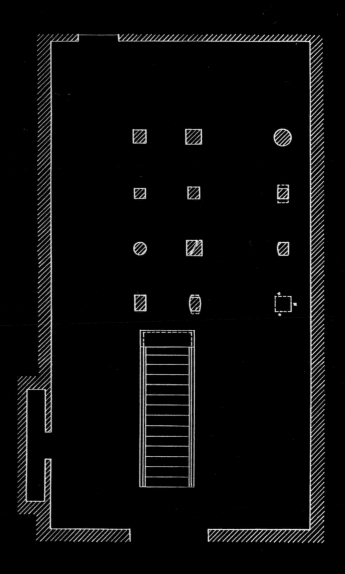

Many of the heads were quite classical, and as I don't consider myself a classicist, this was a problem for me. My architecture isn't at all classical, it's modern in style, more or less minimalist modern, and this approach is quite instinctive. So the exhibition would have to counter the theme of classicism in some way. This is what led me to arranging them on a grid, in a way that seemed to be free of hierarchy. And three rows of four fitted the space. The grid was partly an idea of the time, incorporated by both Bernard Tschumi and Rem Koolhaas into their designs for La Villette, and greatly favoured by Peter Eisenman, who later used it for his holocaust museum in Berlin.

The one thing that seemed important was the way you came into the gallery. You entered directly opposite a staircase, which led down to the basement, forcing you to turn left or right. At the same time, you could see the whole array beyond, and knew not to go down the stairs. So you automatically go left, perhaps because we write from left to right in the western world.

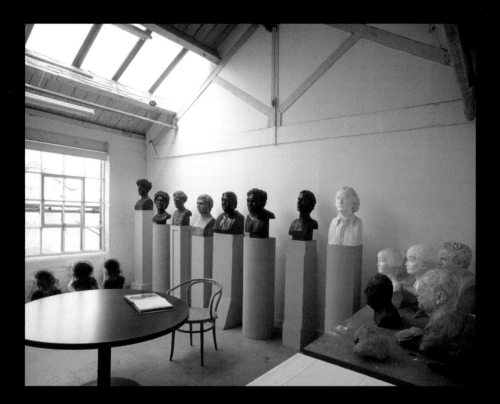

Space Open Studios, Britannia Works, 1997.

Opposite: Figure Heads, John Nichols Gallery, New York, 1991.

The first row of heads now comes on your right, like a one sided street, and they are all looking at you as you look at them. At the back you come round and come forward into a two-sided street, with heads looking at you from both sides. In a way you feel exposed to their view. So it's not a static grid, with all the heads looking in one direction, it has a certain dynamic. The last one is my own head, mounted not on a pedestal but on the stand I used for making it. This gave an impression of incompleteness. Once you have gone through the sequence you can wander freely among all of them and read certain relationships between the works.

On the walls there was nothing to distract you, but in the room behind I hung a lot of images , oversized contact prints of photographs taken during the process, and drawings. They asked me for a title for the show, and I gave it the title *Figure Heads*.

At the opening we had a good party in the back room, I must say John Nichols did me proud, wonderful food, and lots of people came. John was quite impressed, although none of the exhibits was for sale. He said it was the best exhibition he'd ever put on. As it turned out, he had financial problems, and instead of asking me to evacuate the show at the end of the run, he kept the heads in position until March of the next year, it was almost as if he felt the layout was itself a work of art and difficult to dismantle.

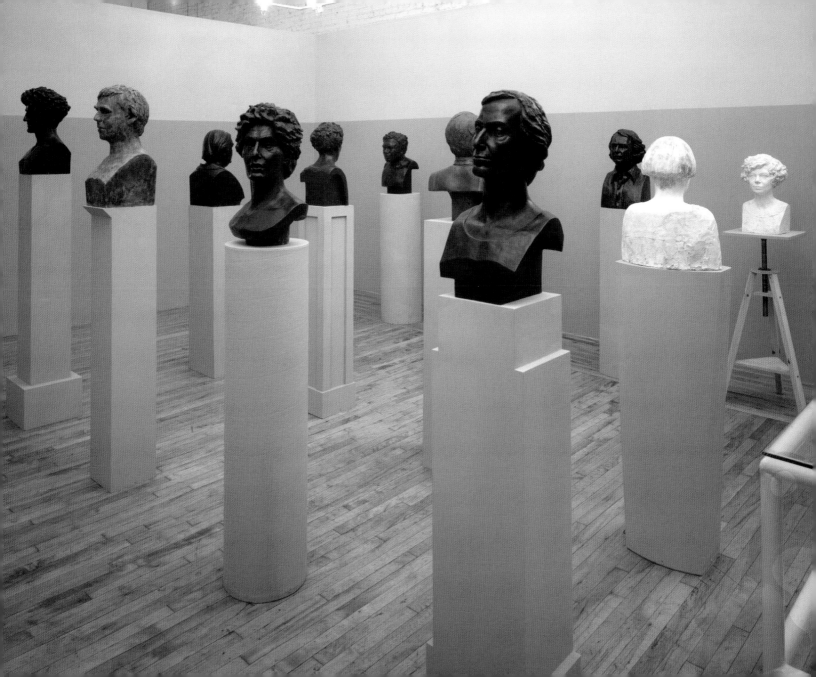

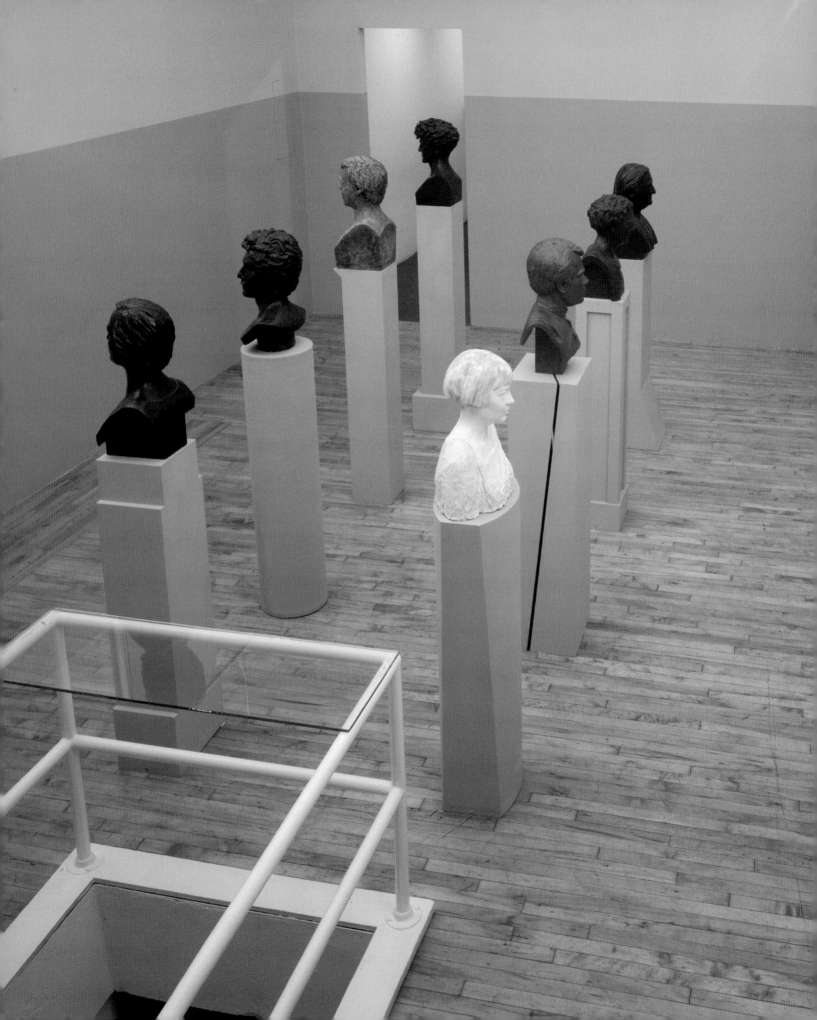

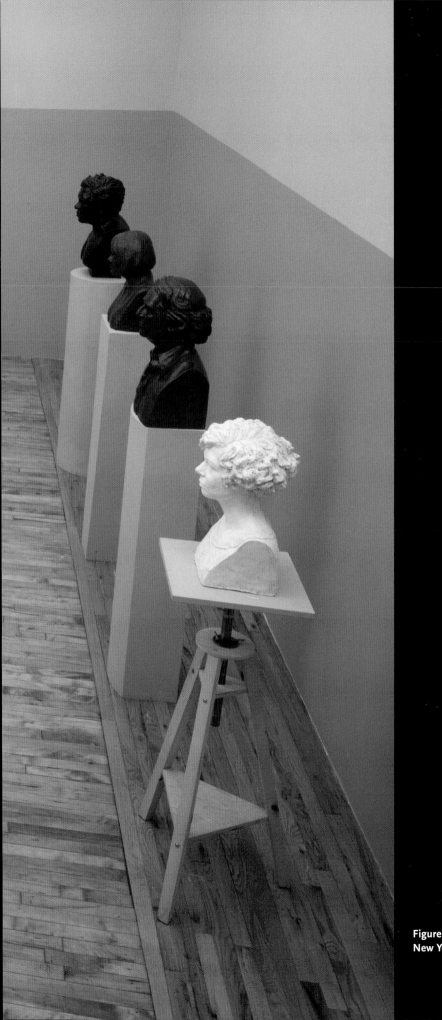

Figure Heads, John Nichols Gallery, New York, 1991.

The Work of Celia Scott
Alan Colquhoun

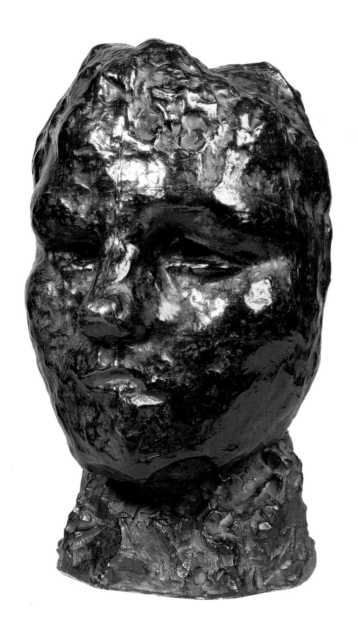

Sculpture always seems to have had a closer connection with public, political space than the other visual arts. For this reason, it has often been associated with a conservative and academic attitude. Most of the artistic innovations of the nineteenth century took place in painting, taking advantage of its ambiguous relationship with real space. Auguste Rodin works such as the *Burghers of Calais*—tried to rescue public sculpture from its regressive associations, by giving it the kind of subjectivity and psychological immediacy that painting had already been exploring for some time, and at the same time trying to bring back the architectural ground to which sculpture had been attached in the pre-modern period. In his *Gates of Hell*, the Bergsonian flux of forms is constantly trying to escape from the architectural frame. Without the frame they would not have the same meaning.

Rodin was acutely aware of the sitelessness of the modern sculptural object. The poet Rilke (who briefly acted as Rodin's secretary), recognising Rodin's nostalgia for an architecturally embedded sculpture, expressed it thus: "Had not the time come that felt again the urge for this form of expression, for this powerful and forcible construction of what was unalterable, chaotic and mysterious?". Yet, for Rilke, the private memory of the viewer was inexorably taking the place of the auratic public space of traditional sculpture. Georg Simmel's view—more

concerned than Rilke with the relation of sculpture with the social realm—as that Rodin's work represented the gap that had opened up in modern capitalist society between subjectivity and objectivity.

Such thoughts force themselves on one as one contemplates the work of the sculptor Celia Scott, whose sculpture exhibits something of Rodin's concerns about the relation of sculpture to collective memory, and the way a sculptural work should be publicly displayed. Above all, she takes up again the thread of Rodin's expressive realism and his passionate interest in the human body and physiognomy. In this respect, Scott's work recalls that of Lucian Freud in painting, although their sensibilities are utterly different. Both artists side-step modernism's multiple developments over the last hundred years. In Scott's case, this does not seem to be due to any principled rejection of modernism (she is, in fact, both interested in and receptive to it, only to any claims it might make to exclusivity). Her style is the conscious choice of a highly intelligent and knowledgeable artist whose instinct and talents lead her to a certain kind of available sculptural expression—one that has ceased to be mainstream, but which is still in a sense part of the collective memory of society, though this memory may no longer be codified or institutionalised.

Scott's work recalls that of Lucian Freud in painting, although their sensibilities are utterly different.

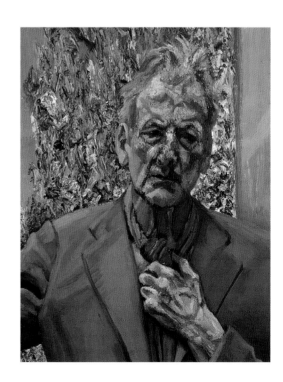

93

In the work of Brancusi, for example, the pedestal is often so elaborate that it begins to defeat its distancing function, becoming part of that which it supports.

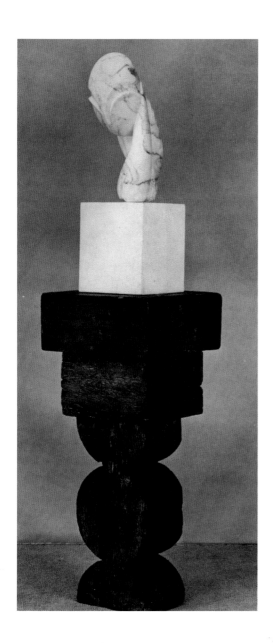

What is the significance of the gap that has opened up between art conceived of as perpetually 'new' and art still seen as the continuation of certain aspects of tradition? Is it simply the difference between two parallel forms of artistic experience, one pursued actively by creative artists and the other received passively in museums—an aberration due to disappear when modern art has finally come to rest as the expression of unified culture? Or is the situation more complicated—a state of unresolved tension in which neither tendency is going to win in a Hegelian sense and in which, nonetheless, there is constant cross fertilisation?

To try to answer such questions it is necessary to look at the history of artistic culture as a whole as it has evolved at least since the middle of the nineteenth century. In one of his essays on Baudelaire, Walter Benjamin addresses this problem with an arresting argument. Baudelaire, he says, based his masterpiece, *Les Fleurs de Mal* on the realisation that the lyric poet had lost his role of minstrel. He had to address himself to a new and more limited audience. In *Les Fleurs de Mal,* Baudelaire wrote a book "that from the very beginning had little prospect of becoming an immediate popular success". This move acknowledged the loss of connection between high art and popular tradition. Yet—as Benjamin also reminds us—Baudelaire's book of poems went on to become a

widely accepted classic. It thus clothed itself with
the prestige previously enjoyed by works of
aristocratically-derived bourgeois art. From this
moment, a situation has emerged in which two
incommensurate standards of public taste tacitly
exist in parallel with each other. But, since avant
garde culture now occupies the position once held
by bourgeois high culture, the surviving practices
of the old culture have been disenfranchised.
They continue to exist, but in a kind of limbo—
thrown into a grab bag whose contents vary from
kitsch to works of high quality.

The work of Celia Scott is among the quite large
class of art works that fall into this category.
To say that her work belongs to the traditional side
of this divide is not to define it with any precision.
It exists in an undefined social context, and has no
specific constituency. One of the main features of
the work is that its end product relies on a craft, in
the literal, old fashioned sense of the word: that of
the centuries old technique of bronze casting. The
commercial survival of this craft, however marginal,
confirms the uneven development within modern
society and the simultaneous existence of different
cultural paradigms.

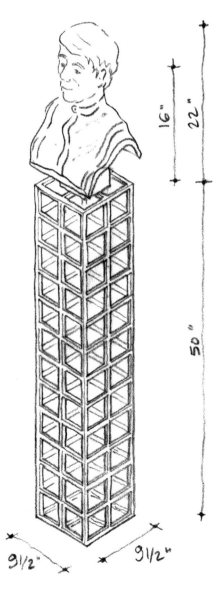

The American Minimalists changed the whole direction of modernist sculpture by again rejecting the work of art as autonomous object, and treating the spatial context as part of the work itself.

Scott's work goes against the grain of modernist practice in a number of ways. It is, for example, representational in a fairly uncomplicated sense, involving techniques of observing and modeling the human subject that go back at least to Rodin. These could be said to belong to a still vital, though recessive, tradition and to involve skills that can still tell us something new about the human subject.

If we turn to the problem of staging or presenting the sculptural object we get a clear idea of the differences and similarities between Scott's work and modernism. An important aspect of modernist sculpture was its concern with the relation of the sculptural object to its environment. In easel painting, the work is distanced from its environment by its two-dimensionality and it exists in a virtual space. In sculpture there is no such filter: the work stands as a solid object with other solid objects in a real space. The autonomous sculptural object, set adrift from its architectural support, has, as it were, to re-negotiate its relationship to ordinary, non-artistic objects. In the work of Brancusi, for example, the pedestal is often so elaborate that it begins to defeat its distancing function, becoming part of that which it supports. The very existence of a difference between the work of art and ordinary objects was deemed to be a idealist illusion by the left wing of the 1920s avant garde, and 50 years later the American

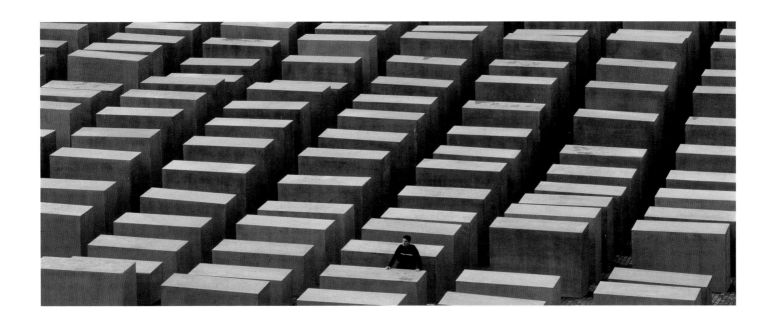

Minimalists changed the whole direction of modernist sculpture by again rejecting the work of art as autonomous object, and treating the spatial context as part of the work itself.

Scott's most important work to date—a group of 12 bronze busts, exhibited in New York in 1991—solves this problem by a traditional method. The busts stand on high pedestals which can be considered a distant cousins of the classical herm. But, unlike the herm, the pedestals are materially different from the busts and they are not abstracted representations of a missing body. Since the busts are supposed to be seen as part of a collection, Scott has made each pedestal slightly different from its neighbour. In a few cases, the pedestal has been given a form that suggests the character of the represented subject, but generally the differences are arbitrary and merely serve to distinguish one bust from another within the set, like the phonemes of natural language.

These games constitute a rhetoric of the staging of the sculptural object that seems as valid for today as it has ever been in the past, if only because it has very little content. What was more questionable was the presentation the group as being united by the theme of historical allegory, for example by the implication they are related to 'worthies' found in

Opposite: Open Modular Cube, 1966, Sol LeWitt, painted aluminium 150 x 150 x 150 cm.

Holocaust Museum, Berlin, 2000, designed by Eisenman Associates.

The idea of the group however, had other, more interesting if less reassuring implications, highlighting the contradiction between the individuality of each bust and its membership of an anonymous set.

the late eighteenth century English picturesque gardens such as Stowe. This idea sprang from an anti-modernist ideology, prevalent in the architectural community to which Scott belonged (though the ideology had begun to wane well before the exhibition took place), which sought to bring back meaning and memory into a practice dominated by literal functionalism. But today it is difficult to believe that any revival of meaning could be achieved by returning to a highly encoded, classically orientated past in which meaning was dependent on a set of very specific literary conventions.

The idea of the group, however, had other, more interesting if less reassuring implications, highlighting the contradiction between the individuality of each bust and its membership to an anonymous set. This contradiction had no doubt originally become evident when the sculptural object was separated from its architectural ground and became one of a number of autonomous and freestanding objects in a museum space. But in arranging them on a mathematical grid, Scott was rubbing salt into the wound and seemed to be denying them any ideal, individual content. Like soldiers standing to attention they become emblems of the dehumanised mass recalling Sol Le Witt's grids, or the 'tombs' of Eisenman's holocaust museum, identical except for almost imperceptible differences of geometry, just as

Scott's are different only in the slightest changes in the pedestal and just as, biologically human beings are identical except for minute surface characteristics.

We should beware, therefore, of considering Scott's talents as purely those of a realist concerned only with the idealised individual body. Other agendas are at work and it will be fascinating to see if she will be able to integrate them with the tradition in which she seems most naturally at home: that of the late romanticism of Rodin.

Installation of Robert Morris'
work at the Green Gallery New York,
December 1964–January 1965,
painted plywood.

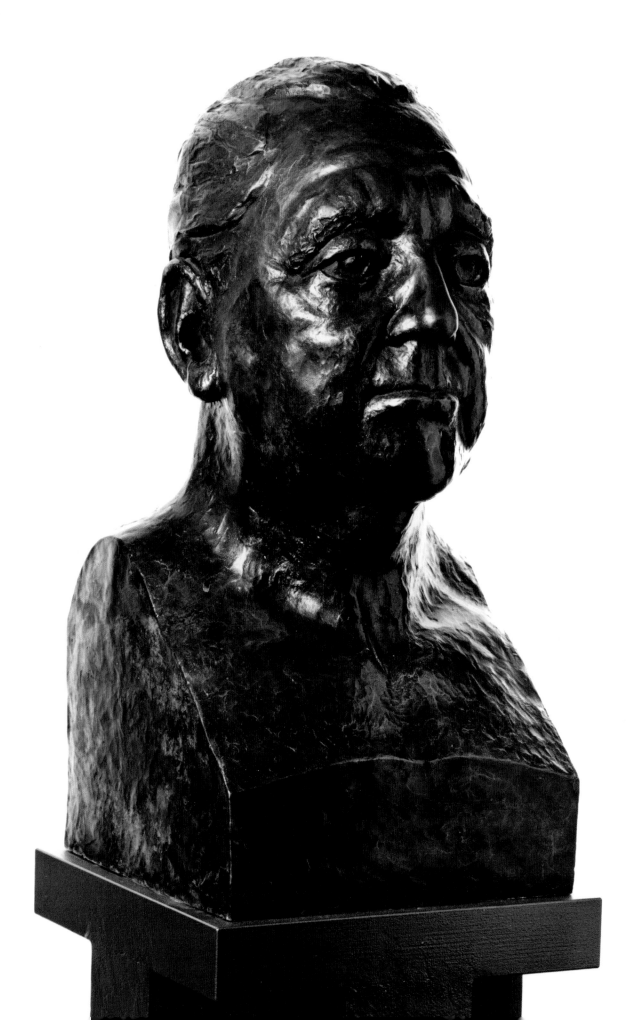

Mies van der Rohe

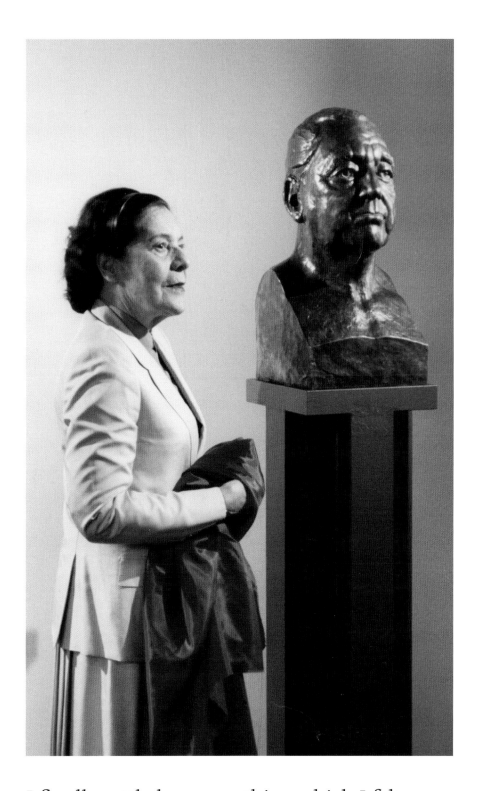

I finally settled on something which I felt
had had something of the Neue Sachlichkeit
as well as the classical. I was thinking of
the turning point in Mies' life, when he had
to close the Bauhaus in Berlin, and went
to the United States.

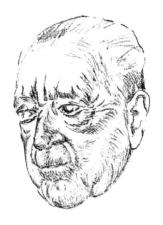
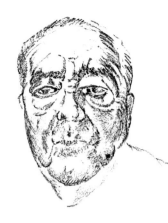
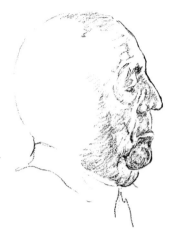

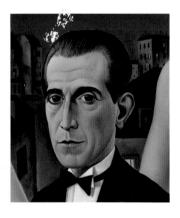

Then, in the aftermath when I was in Princeton and feeling a bit empty, the unexpected struck again. There came an invitation from the Friends of Mies van der Rohe in Aachen to provide a head of the great man. Someone already dead, someone I had never known. I thought it impossible, and declined. But then Alan Colquhoun and Anthony Vidler came by and said, "but of course you must do it". I started collecting photos of Mies, and realised they were few and far between as it turned out that he had most photographs of himself destroyed. Then someone put me in touch with Dirk Lohan, his grandson, an architect working in Chicago, who kindly leant me some unpublished photographs of Mies without which I could never have undertaken the project.

The head was to go in the entrance hall to a new school building in Aachen, in Mies' home town, the same school that he had attended, but on a different site, and they were anxious to maintain the link to Mies, indeed, the school was to bear his name. There was little time as it had to be ready for the opening of the new building. This gave me five weeks to model the head.

So I called up Eduardo in London and he persuaded Chris and Gaby Nash to lend me studio space in their foundry in Putney. The space was right next to a studio in which Eduardo himself was working on a large figure he was making up out of plaster fragments.

I stayed with Mary Stirling and worked during all the daylight hours at the foundry. I made drawings from the photographs, read a biography and talked to some people who had known him. I remembered my lessons from Banham long ago and my days with architects Yorke Rosenberg Mardall. The head went through several stages, Eduardo, in one of his comments as he passed by my studio, suggested I take casts of each stage, but there wasn't time. I finally settled on something that I felt had had something of the Neu Sachlichkeit as well as the classical. I was thinking of

M. R. Thoma: Die »Charakterköpfe« von F. X. Messerschmidt, Lithographie, 1839.

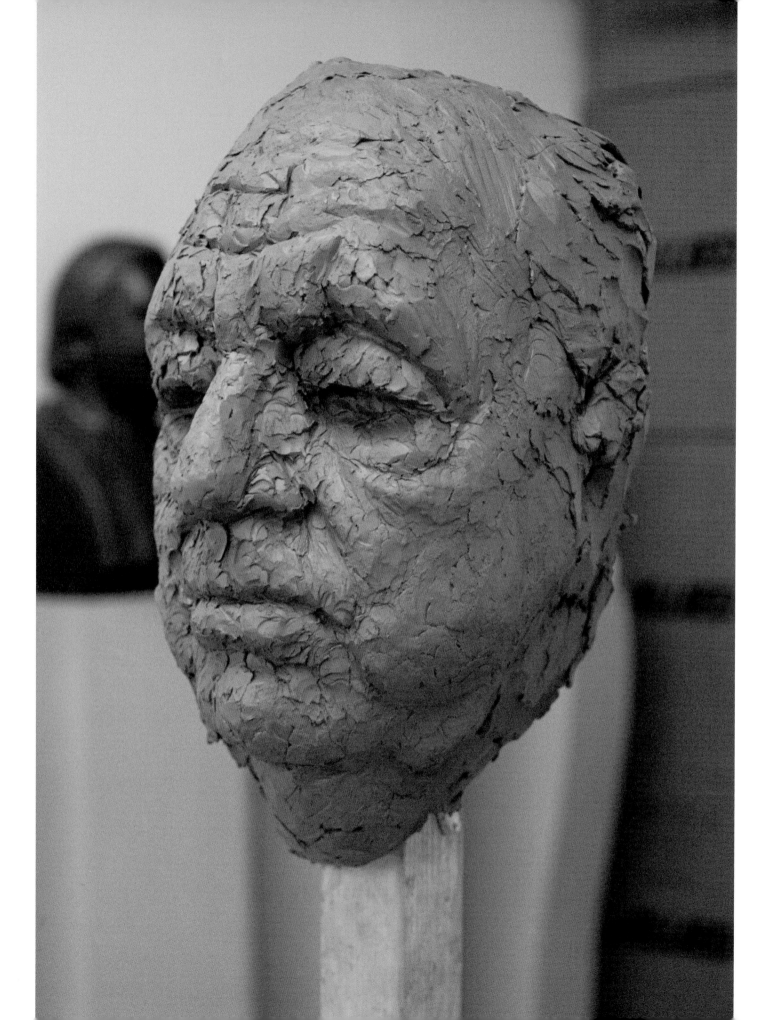

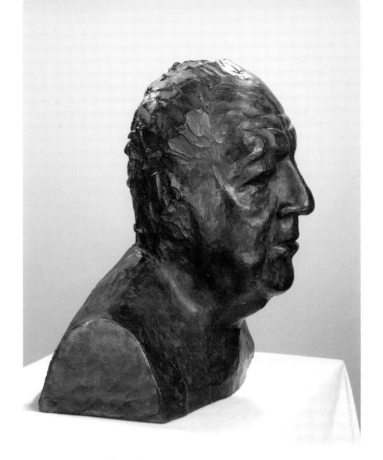

Opposite: Mies van der Rohe,
Version 2, clay in process, 1994.

Mies van der Rohe, Version 2,
1994, bronze, approximately
46 x 40 x 36 cm.

the turning point in Mies' life, when he had to close the Bauhaus
in Berlin, and went to the United States. Berlin was the place
of German culture and Christian Schad's painting of the Count
St Genois d'Anneaucourt seemed to epitomise this visually. Chris
and Gaby were most helpful and got the bronze cast very quickly.
To save time I would have to deliver the cast myself to Aachen.

There the bust, which was just over life-sized, was mounted
on a base made in steel in a form similar to one of his typical
crucifix columns, as used in the Berlin Museum. The base
and installation were designed by Marlies Hentrup, a friend
of James Stirling, and was unveiled by Mies' daughter Georgia.

I had to do the Mies head so quickly that I felt vaguely
dissatisfied. It seemed a bit stiff and forbidding, and at the
end of his life his features had rather disintegrated. So for
my own satisfaction I decided to do another one. It brought
out some of my own feelings about Mies, his classicism
and so on, about which I felt an ambivalence, and it's a bit
more expressionistic in style than my original attempt.
It was a try-out, and I suppose I was beginning to think
more deeply about the problems of doing likenesses rather
than making heads.

TS Eliot

But I had to accept the concession of giving him a collar and tie. As I worked I listened to recordings of him reading his poetry

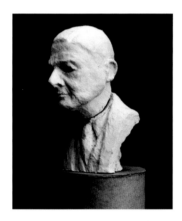

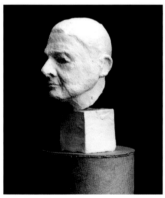

TS Eliot maquettes, 1996 Celia Scott, plasteline and cardboard, approximately 12 cm high.

Opposite: TS Eliot, 1997, Celia Scott, bronze, 48 x 26 x 31 cm, British Library, London.

Then, I was approached to do a head of TS Eliot, another dead subject, to go in the British Library. At the time there was a controversy raging about whether TS Eliot was anti-semitic. But I re-read some of his work and this time I did not say no, although I still had reservations about working from photographs alone. This head was to go in the ante-chamber of the Rare Books and Manuscripts Library and would be paid for by an anonymous donor.

Eliot's widow, Valerie, was around: she invited me to her flat, entertained me with copious glasses of gin and salmon canapés, and showed me the photographs which she felt were most like him. These photographs made the project feasible. His appearance was remarkably consistent throughout his adult life, always the carefully-combed hair, the three-piece suit and tie.

So it was with some trepidation that I started on it. Valerie would have to approve it. I was now back in England living in Mall Studios, but with a studio space in Britannia Works in east London. There was no pressing time limit. Again I made drawings from photographs and made maquettes with different bases. I tried the modern form of an isolated head on a cube, but found that something of the bust form had to be brought back, to counter balance the way I had modelled him leaning forward. It worked better and gave him more of an intensity. But I had to accept the concession of giving him a collar and tie. As I worked I listened to recordings of him reading his poetry.

Eventually, I thought it was finished, so it was arranged for Valerie to come to Mall Studios and view it. I saw her coming down the lane, smartly dressed in high-heeled shoes, wearing white gloves and bearing a huge bouquet of flowers, so I was apprehensive. However, the meeting went off very well, and she was very happy and gave us a slap-up lunch at the Savoy.

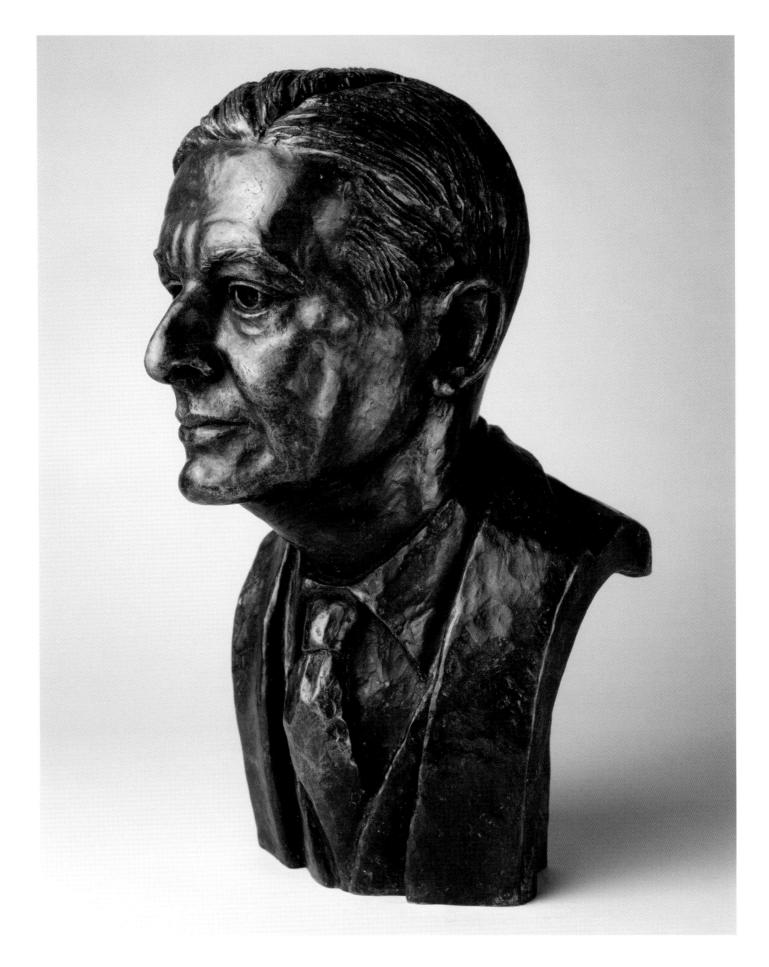

TS Eliot, preparatory drawings, 1996,
pencil on paper, 30 x 60 cm.

Opposite: TS Eliot, detail, 1997,
Celia Scott, bronze.

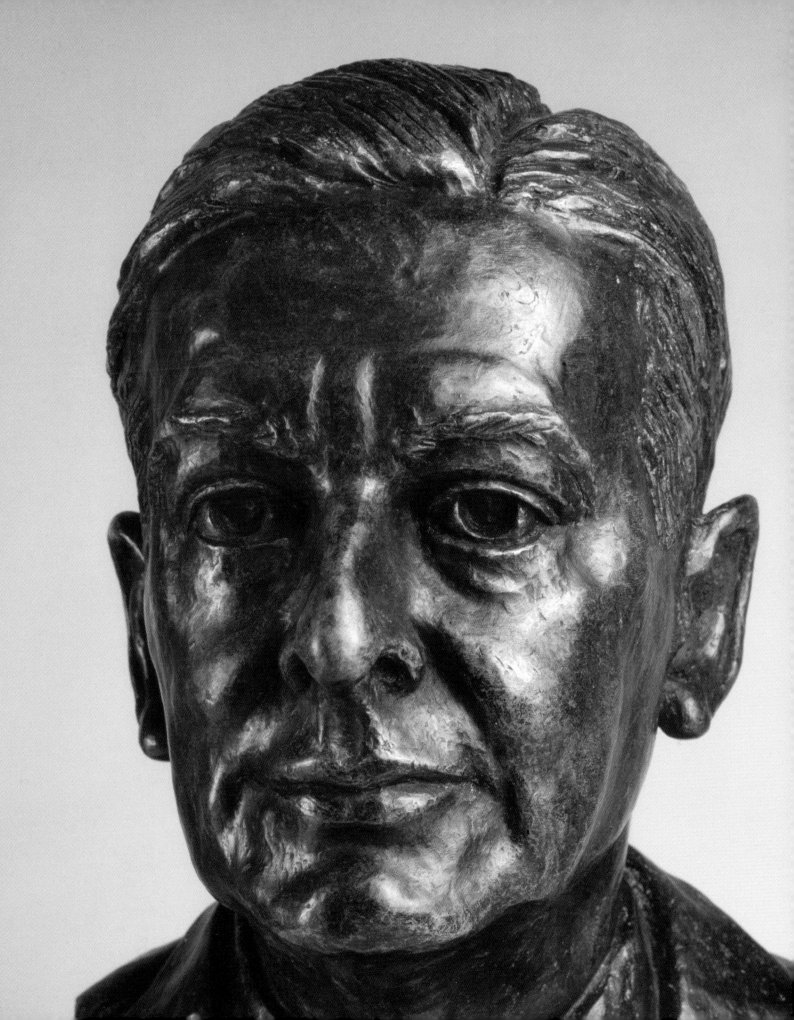

Sandy Wilson

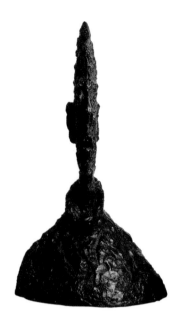

I felt as a modernist, his head should take a modern form.

Before long Sandy Wilson asked me to do a head of him. I took this very seriously. I knew him to be a serious judge of art; indeed the gift of the Wilson Bequest to the Pallant Gallery in Chichester has provided a major review of British art, and proves what a sharp eye for art Sandy had. I also knew that he had had portraits of himself done by Kitaj, Michael Andrews, and earlier on, Coldstream, so I had something to measure up to.

He came regularly for sittings at Mall Studios. I drew and measured. I took photographs, but the photographs never looked like him. At rest his face looked glum and gave a quite different impression from when it was animated by talking, when it appeared quite boyish. He didn't mind "looking grim", as he called it, as he felt that his 30-year struggle on the British Library had made him something of a martyr. In fact, he suggested I look at Chantrey's bust of Hawksmoor as a reference.

I felt as a modernist, his head should take a modern form. I tried the head on its own, and had it directly mounted on a block of slate for Sandy. I was not quite satisfied with this, and searched around for a way of extending the figure down to form a base, without being classical. Sandy frequently wore a red scarf. This is what led to the idea of using his scarf to form the base, the garment on its own, no body. In the event, this head was provided to the British Library, and is mounted in a niche in the entrance hall, just to the right as you come in, as the head of the architect. It was donated to the Library by the American Friends of the British Library.

Left: Sandy Wilson, working clay in process, 1996, some of Scott's contact prints at an early stage.

Right: Large Slicing Head, 1954, Giacometti, bronze, 65 cm high.

Opposite: Sandy Wilson, Version 2, detail, 1998, bronze, 33 x 20 x 20 cm.

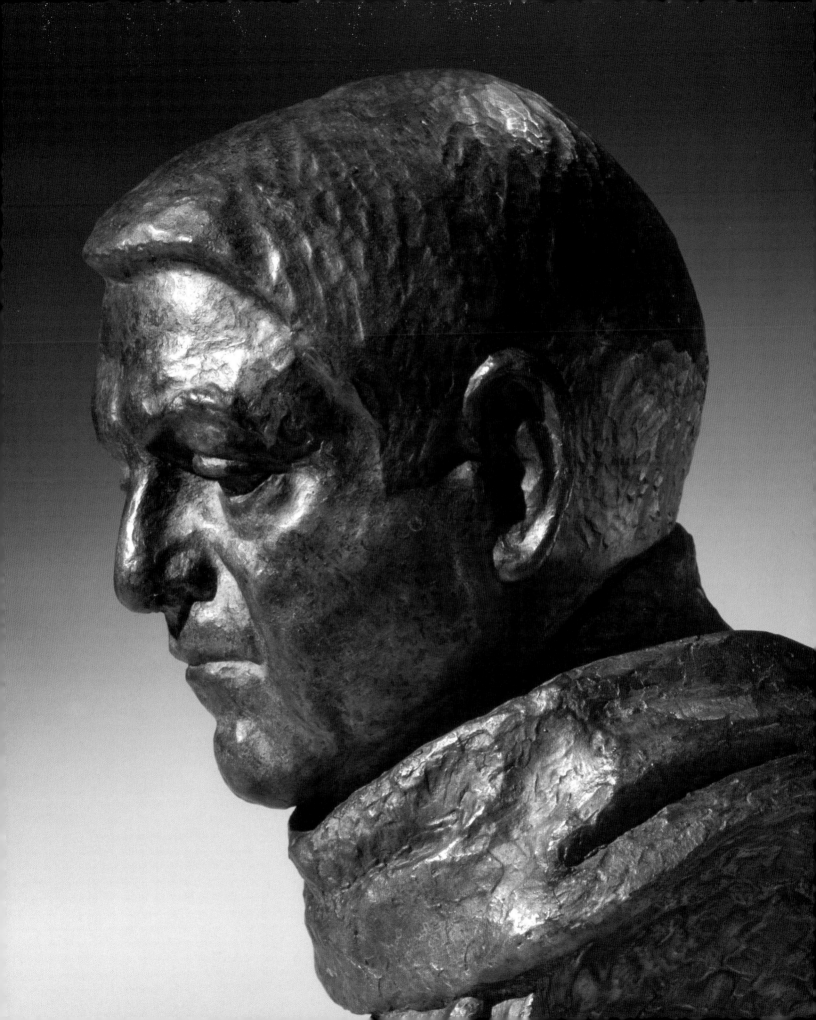

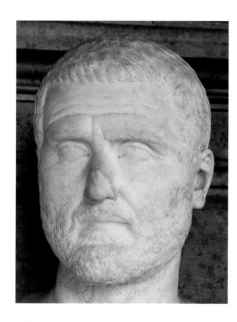

Left: Emperor Gordian I, third century AD, Roman bust, marble, Capitoline Museum, Rome.

Right: Sandy Wilson, Version 1, 1996, Celia Scott, bronze and slate, private collection.

Opposite: Sandy Wilson, preparatory drawing, 12 May 1995, Celia Scott, pencil on paper, 35 x 28 cm.

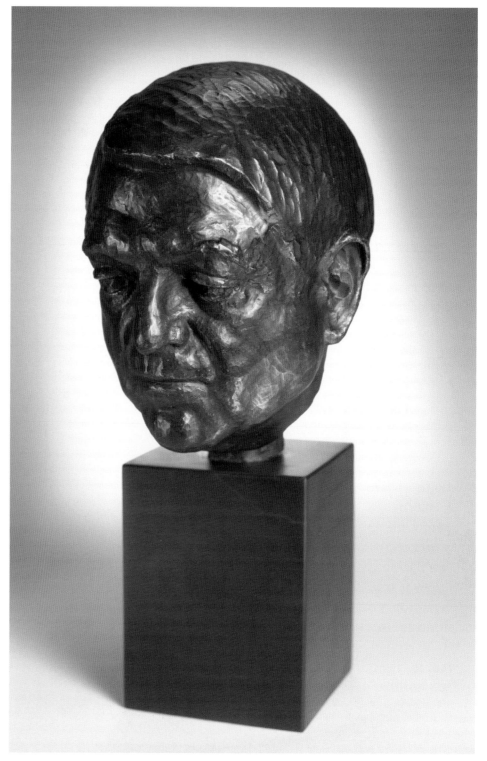

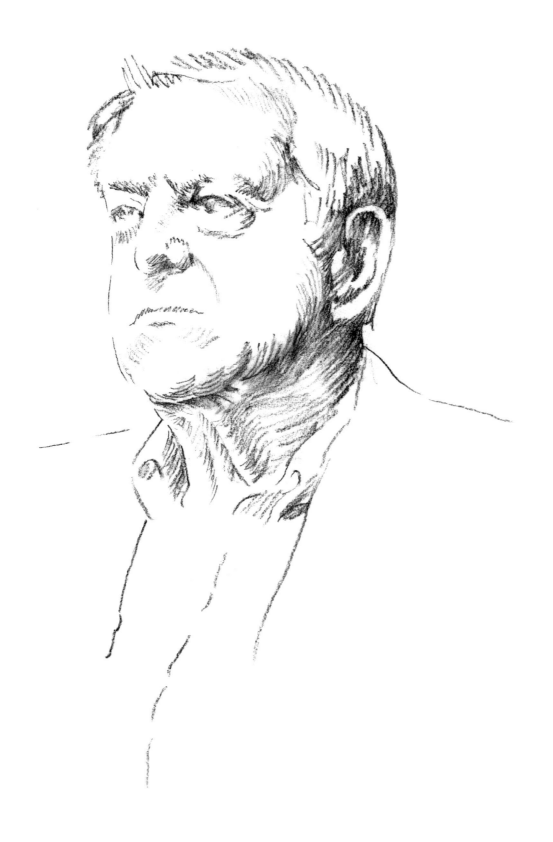

Sandy Wilson, Version 2, 1998, Celia Scott, bronze, 33 x 20 x 20 cm, British Library, London.

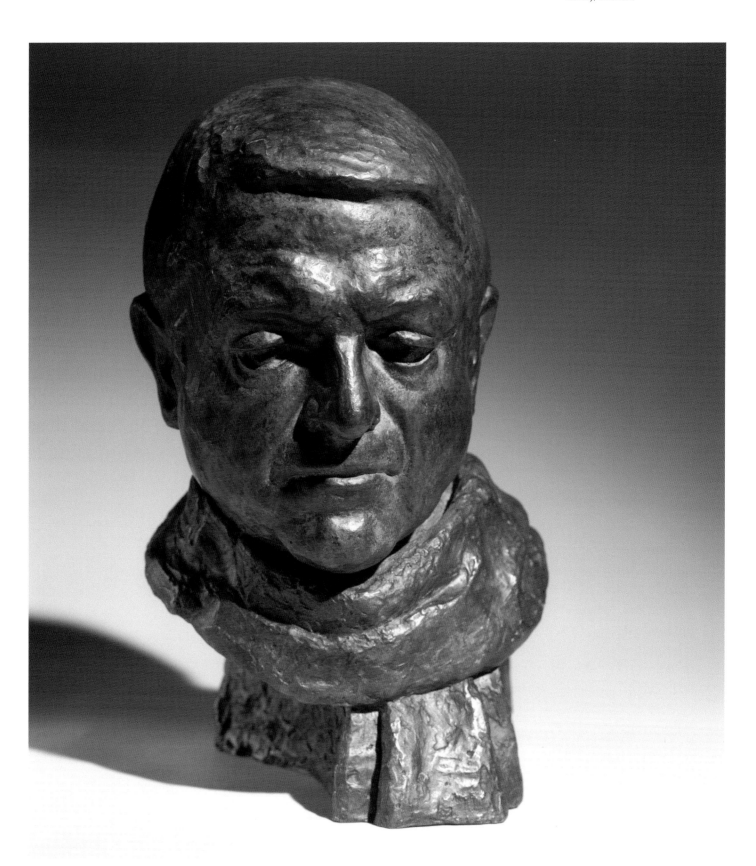

Colin Rowe

He was an architect and critic who greatly influenced many of the people who were in the New York exhibition, and particularly James Stirling.

Friends said that one head that was missing was that of Colin Rowe. He was an architect and critic who greatly influenced many of the people who were in the *Figure Heads* exhibition, particularly James Stirling. In some ways he was the pivotal figure of that generation, respected also by Reyner Banham. But he died in 1999, and although I have photos, and could get more, I had known him myself, and this made it more difficult to think about. When we came back from his celebration in the UnitedStates I even had a death mask of him, but this seemed to make it all the more gruesome, and it didn't even look like him.

Around this time Sandy Wilson's artist friends were asked to produce a small-scale work to put in a scale model of the art gallery he was designing at Pallant House in Chichester. The model and its contents were a surprise present for Sandy. I decided to make a maquette, or small version of Colin Rowe's head for this. Developing the theme of Sandy's scarf base, I used Colin's arms as a support for his head. Colin had sensitive long fingers. I had not been told what scale the architectural model was to be, only that my maquette should be not more than ten centimetres wide. My piece was within this dimension, but seemed so over-scaled inside the architectural model that it, along with a piece by Tim Scott, which also appeared over scale, was not included in the model. I called the piece *Colin for Colin* (Colin being Sandy's given first name) and gave a bronze cast of it to Sandy.

Colin for Colin, 2000, Celia Scott, a momento of Colin Rowe for Colin St John (Sandy) Wilson, bronze, 10 x 15 x 6 cm.

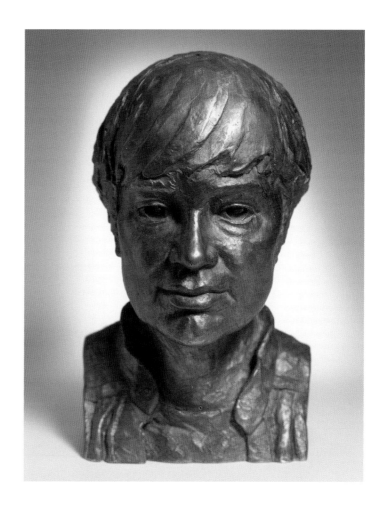

MJ is a very straight person, so I did her straight on, no frills.

By now, I had Sandy's confidence, and he proved to be a good patron to me. When I suggested that I should do a head of his wife, she agreed. His wife was MJ Long. She had been my teacher at architecture school and she is currently a professor at Yale. I admired her as an architect, wondering whether she had been given full recognition for her work on the British Library, not to speak of the Cornford house, where she first worked with Sandy. For her, I reverted to the bust form, but in a modest way that you are hardly aware of. At the back of my mind were the Egyptians again. I knew that when they worked in stone they carved from each of the four sides of the block. Frontality seemed important.

MJ is a very straight person, so I did her straight on, no frills. I thought the full-on pose would represent her strong and direct character. I did give a lot of thought to the patina, and the bronze patina is near to the natural colour of bronze, the metal itself. The dark brown with a touch of gold was the result. I felt this appropriate to her modernist approach in architecture.

MJ Long, 1996, Celia Scott, bronze, 33 x 20 x 20 cm, private collection.

Opposite: Studio, 2000, with plaster casts, clockwise from below: heads of MJ Long, Richard Meier, with Celia Scott in background.

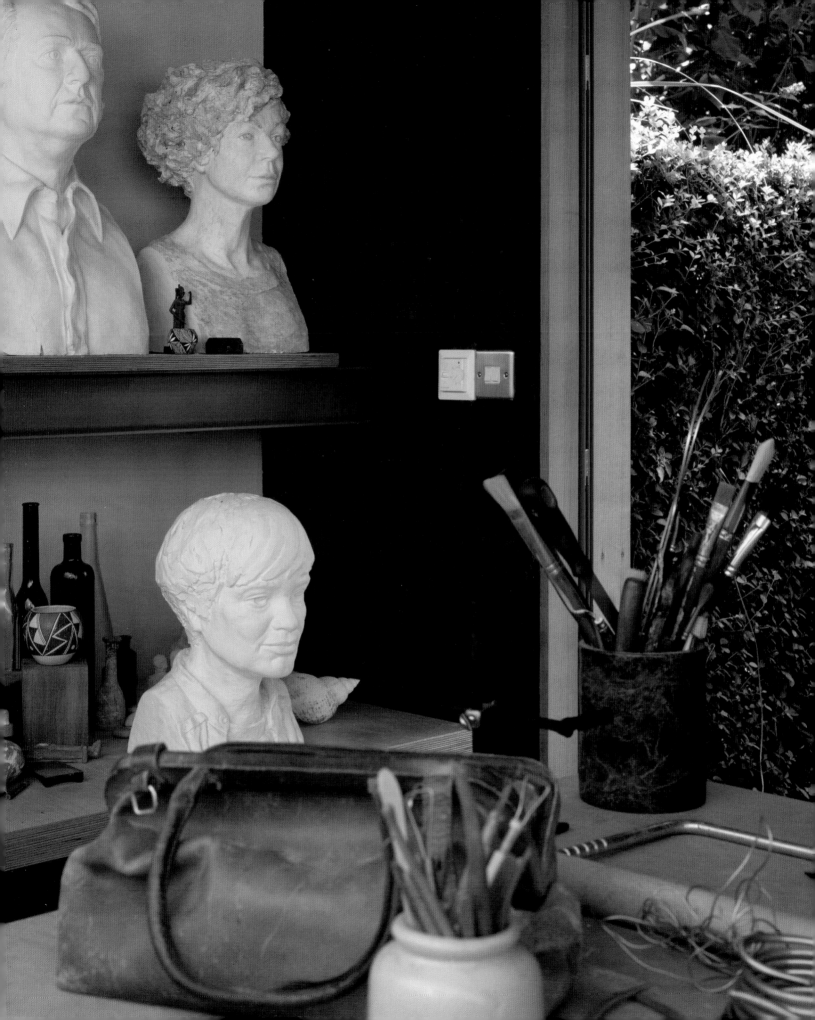

The unexpected again: I had a letter from the Museum of Modern Art in Ostend, Belgium, asking to review my work. From photographs they picked the heads of Eliot, Sandy Wilson and MJ, to be included in an exhibition of figurative art in February 2001, under the title of *Between Earth and Heaven, New Classical Movements in the Art of Today*. It was curated by Ekaterina Andreeva, Agnes Rammant and Edward Lucie-Smith. The exhibition was intended to examine the many viewpoints on the subject of the inherited traditions of classical art. Not only nostalgia was encouraged but also more critical stances, looking for aspects relevant to today's problems or looking for extremes through the use of irony, and even sarcasm. In the event, construction work on the new museum building delayed the opening of the exhibition by several months. There were a lot of discussions and interventions by the local community, and the exhibition became less selective than was originally intended. But my three heads were included, placed in a row. I gave them different titles: *The Poet, The Face of Care, A Woman in Power*.

Left: MJ Long, detail of plaster.

Right: MJ Long, working clay in process, 1996, contact prints

Opposite: MJ Long, 1996, Celia Scott, bronze, 33 x 20 x 20 cm, private collection.

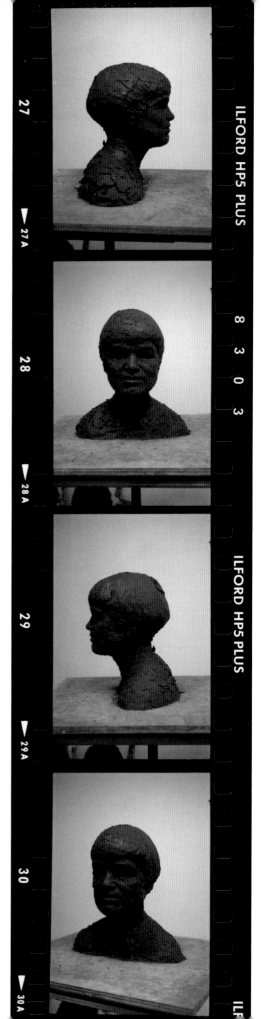

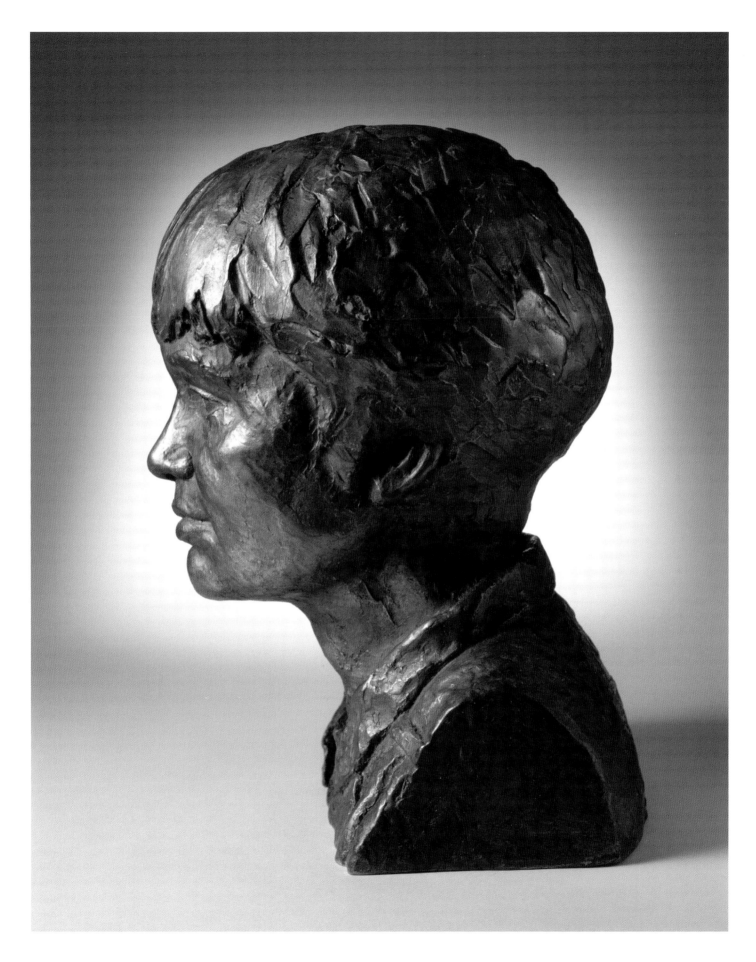

Terry Farrell

A Prisoner, detail,
Michelangelo Buonarotti (1475–1564).

Opposite: Terry Farrell, detail, 1999,
Celia Scott, bronze.

Overleaf left: Terry Farrell,
working clay in process, 1999.

Overleaf right: Terry Farrell, 1999,
Celia Scott, bronze, 60 x 45 x 35 cm,
private collection.

Besides which, I thought he had an interesting head, so I just enjoyed myself with him.

Terry Farrell was the architect for refurbishment of the Dean Centre in Scotland, which was to house a lot of Eduardo Paolozzi's work. Sue Farrell approached me and asked me to do a bust of Terry, to be put in the entrance hall. By now the classical model didn't seem so relevant, I had lost my inhibitions about trying to make a likeness, and was thinking more and more of Rodin. I had known Terry since he taught at the Bartlett when I was there. Although his style of architecture is somewhat eclectic, he has thought seriously about the continuity of the city, and has a formidable reputation as an architect-planner. Besides which, I thought he had an interesting head, so I just enjoyed myself with him. He is an expansive character, so I gave him plenty of body, and I had no qualms about leaving the edges of the bust rough and uneven. He came for sittings in Mall Studios and the head was completed after eight visits.

But the plan to install it at the Dean Centre faded, so the Farrell head loiters in his studio. His family is amused by it, he looks jovial as well as life-like.

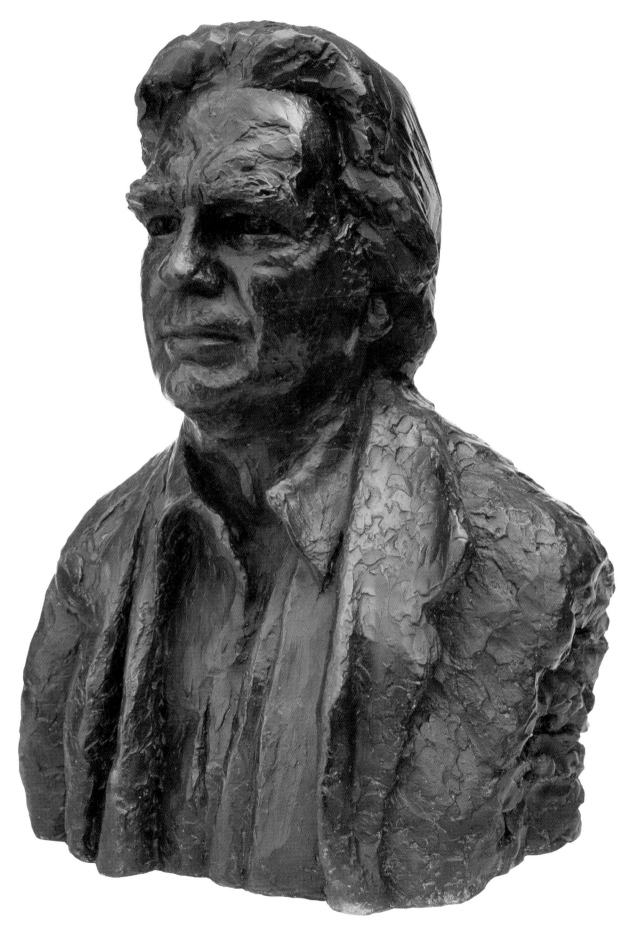

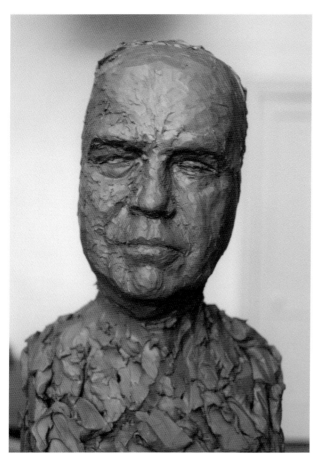
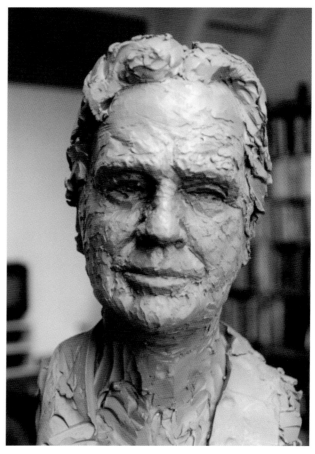
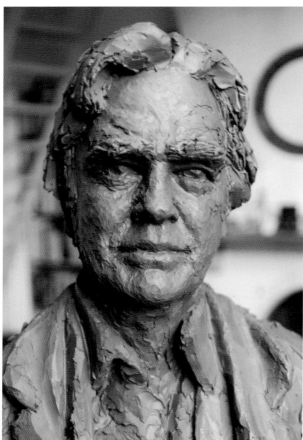
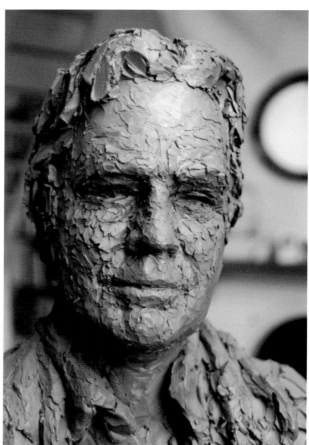

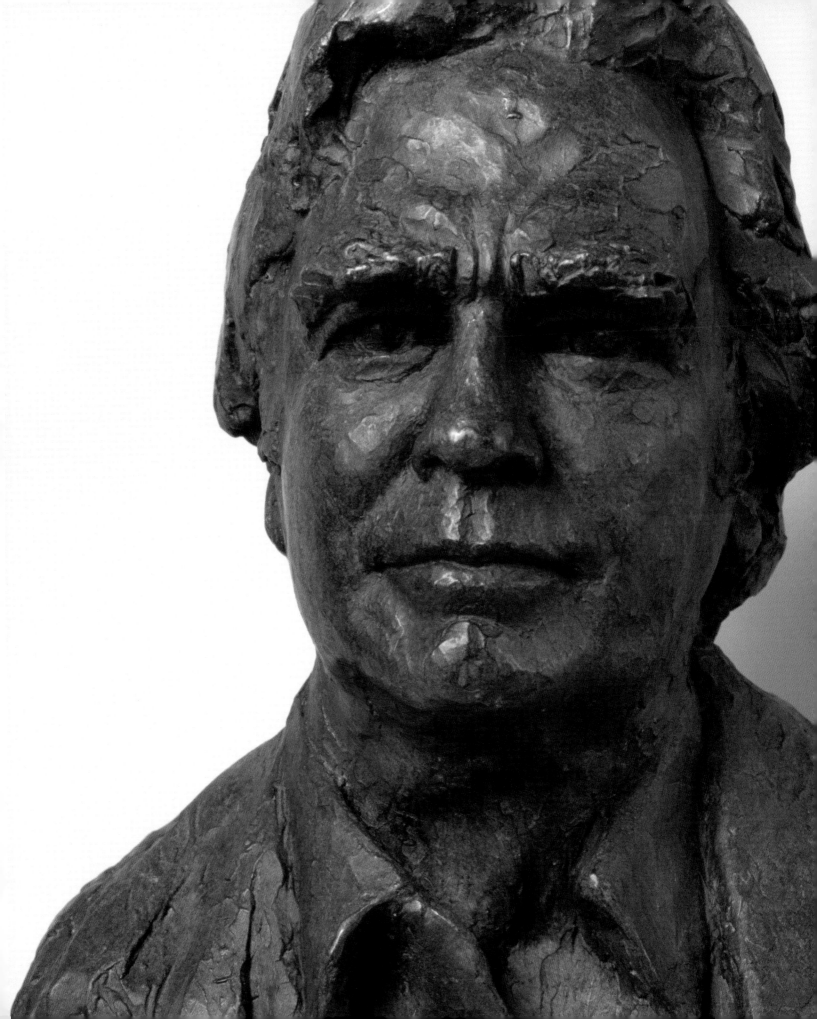

The Studio

Scott's garden studio in
Belsize Park, 2000.

Opposite: Studio, open doors.

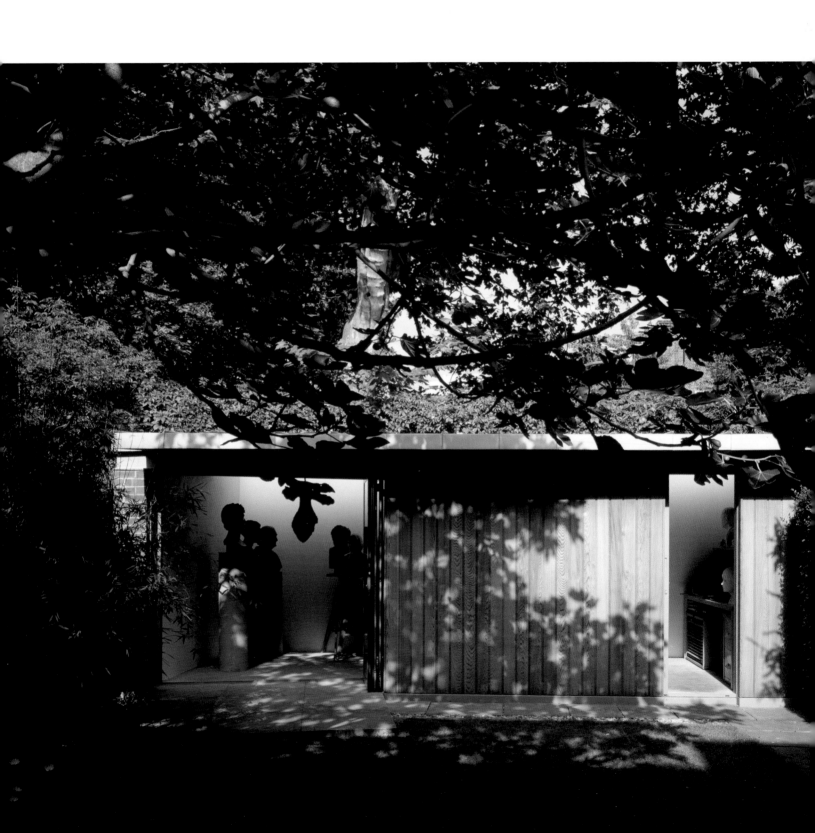

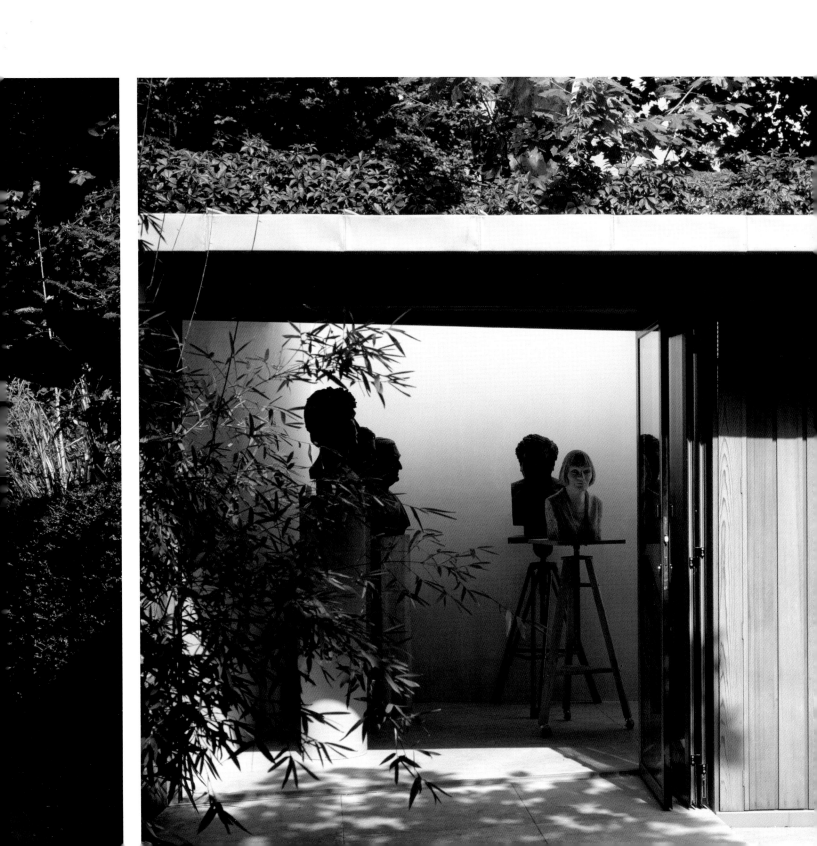

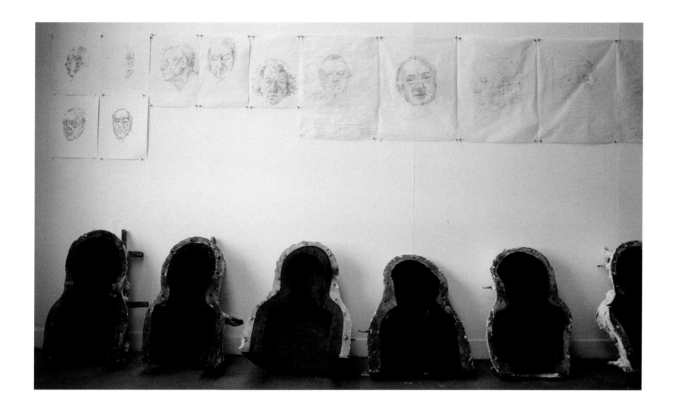

As a work space, it's a little small, but quiet and peaceful.

It was around this time that I decided to build myself a studio where I could work without messing up the house. We have a back garden that is about 25 feet wide and deep enough so that we would still have space for a lawn. So I designed a building that was about eight metres long and three metres deep, with a nearly flat but slightly sloping roof clad in tern-coated stainless steel, a floating plane that projects out on the side facing the house. It has a top-light that tapers slightly, to vary the amount of light, running along its length at a slight angle. On three sides, the boundaries, the walls are built of cavity brickwork, to make it impervious to plant growth. Two steel beams span the long dimension of the space countering the two wooden trusses that run in the opposite direction in the main studio.

There are two windows, which are also doors: the entrance door slides away into the wall, and the large window at the other end is a sliding and folding door. It gives on to a terrace facing the afternoon sun, which is slightly turned towards the south. The wall between the windows is made of timber, and lined on the inside with cork, to make a pin-up board. The plaster is self-finished, just off-white in colour, where the floor is polished concrete (giving the appearance of stone) and supported by piles to protect it from tree roots. The studio has a sink, electricity and under-floor heating, but no phone. As a work space, it's a little small, but quiet and peaceful.

Moulds in a row at Britannia Works, East London, 1996.

Opposite: Belsize Park Studio, 2000.

Overleaf: Workbench at Britannia Works, 1997.

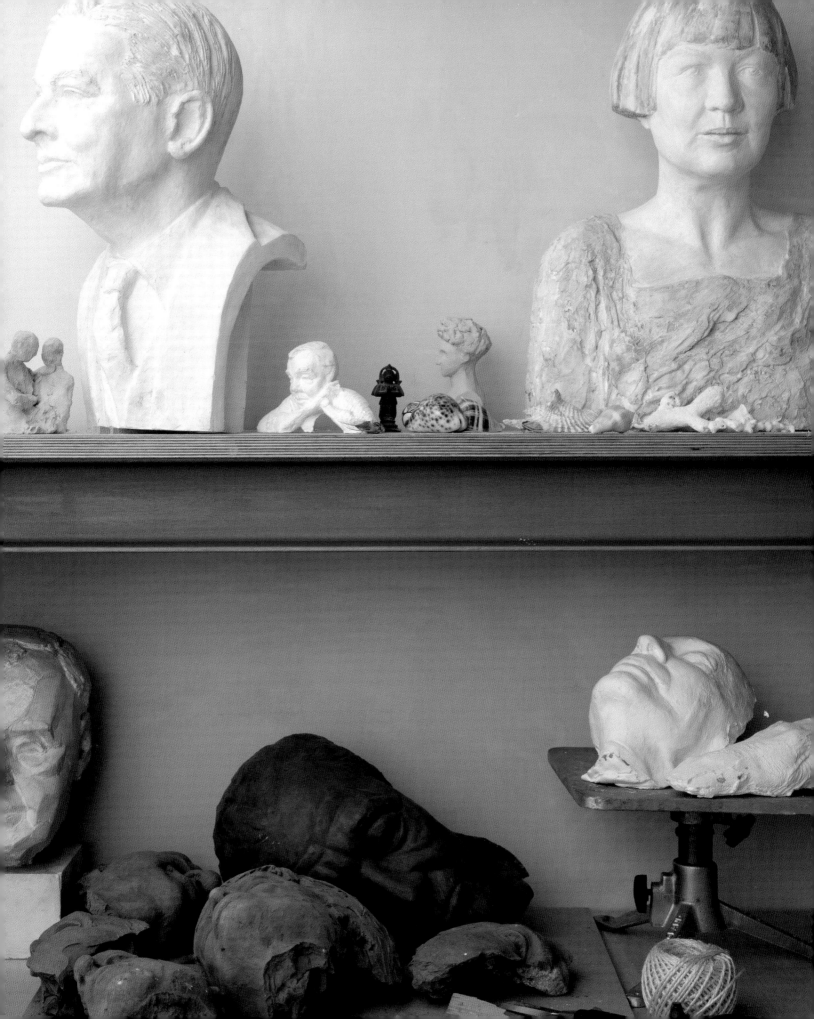

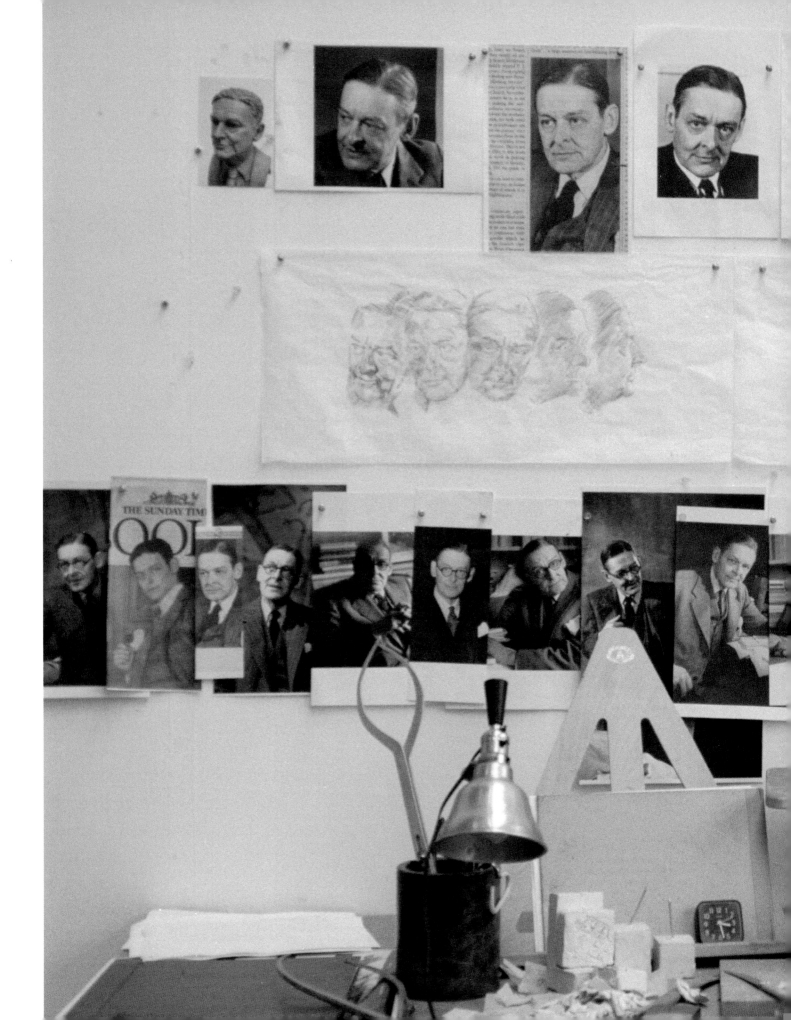

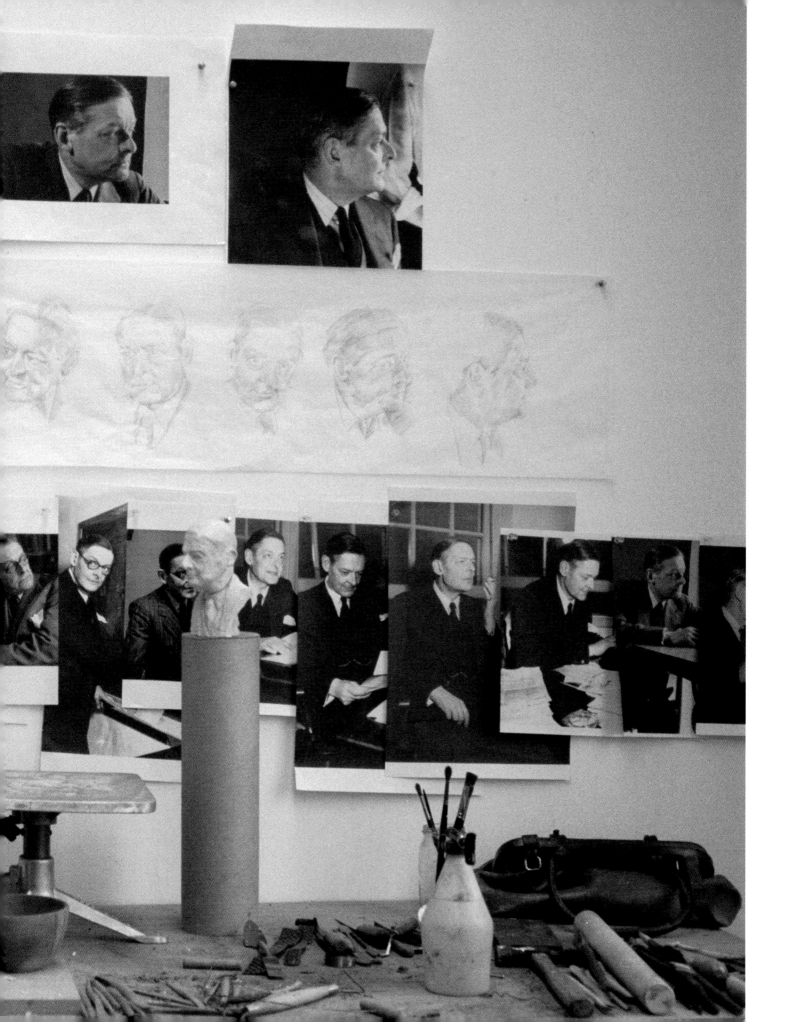

Richard Godwin-Austen

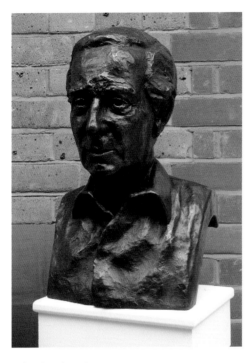

Richard Godwin-Austen,
2003, bronze.

Opposite: Richard Godwin-Austen,
working clay, 2002.

The great benefit was, he was not an architect, and this was some relief.

Up until now, since I was an architect, the majority of the heads I had done were of architects. The selection was quite accidental, they were simply friends.

The next proposal came from a friend who was in America at the same time that we lived there. She wanted a bust of her husband to give to him as a present. As she was an old friend, I agreed. The first sitter in my new studio was Richard Godwin-Austen, an eminent neurological surgeon.

The great benefit was, he was not an architect, and this was some relief. At first, I began to feel a curiosity about his psyche, and tried to portray it. So there is a man within a man in some sense. For some time it stood in the hall of their Georgian house, which provided a fine setting for it.

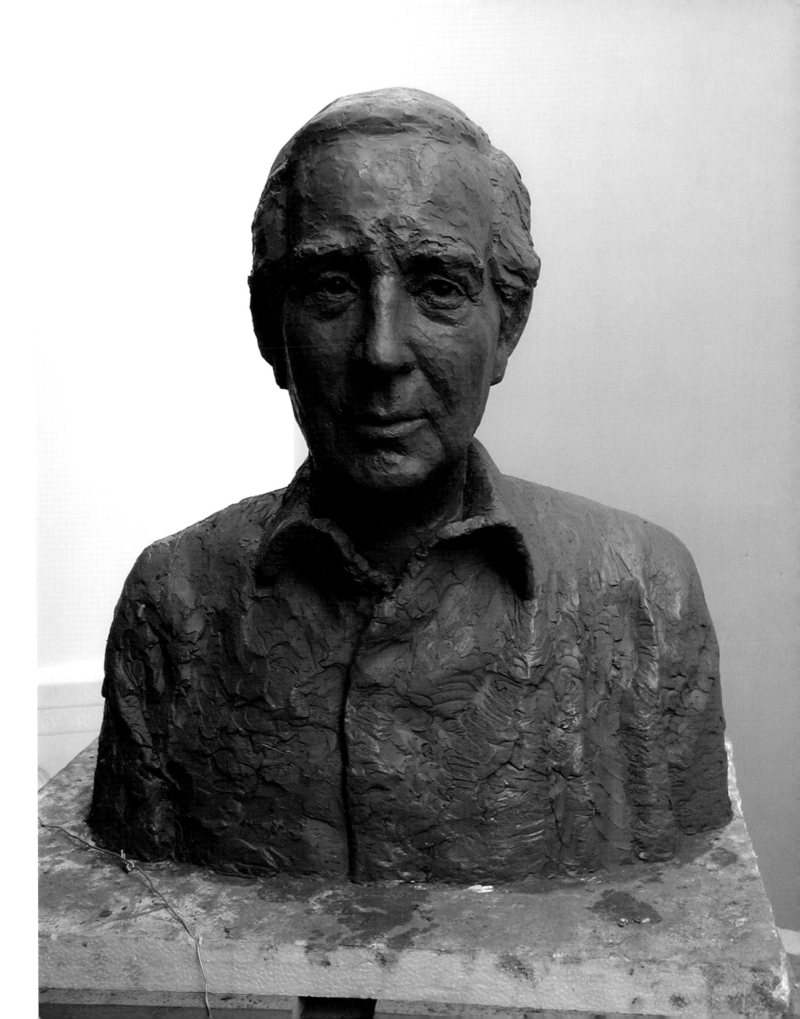

Harry Wilson

He started out the sittings as a care-free surfer, and this made me turn to a sculpture of Buddha for inspiration.

The problem with portrait busts for the artist is that people tend to be more interested in the person portrayed, and whether they are worthy of portrayal, than the way it is done. I was working on some preparatory drawings for war reliefs. So when Sandy Wilson asked if I would be interested in doing a head of his son Harry, I accepted. Harry has a striking head and at that time you could see the form clearly as he wore his hair one or two millimetres long. It was a style of the time, but his was one of the few heads that could take it. Modelling it turned out to be quite difficult, as I had set myself the task of doing a likeness, but restricting it to the head, so there was no posture, no clothing or hair to play with. But also I did not want to over-simplify it by abstracting too much. It was difficult not to exaggerate the size of his distinctive skull. It went through several stages, while Harry went off to travel the world. He started out the sittings as a care-free surfer, and this made me turn to a sculpture of Buddha for inspiration. At this stage it looked quite powerful. Returning from the other side of the world and getting down to work, his character had changed. It was cast in bronze with a grey patina, which looks almost like lead, and is mounted on a Portland stone block.

Buddha, Guimet Museum, Paris, 2003,
Celia Scott, pencil on paper.

Opposite: Harry Wilson, 2004,
Celia Scott, bronze on Portland stone.

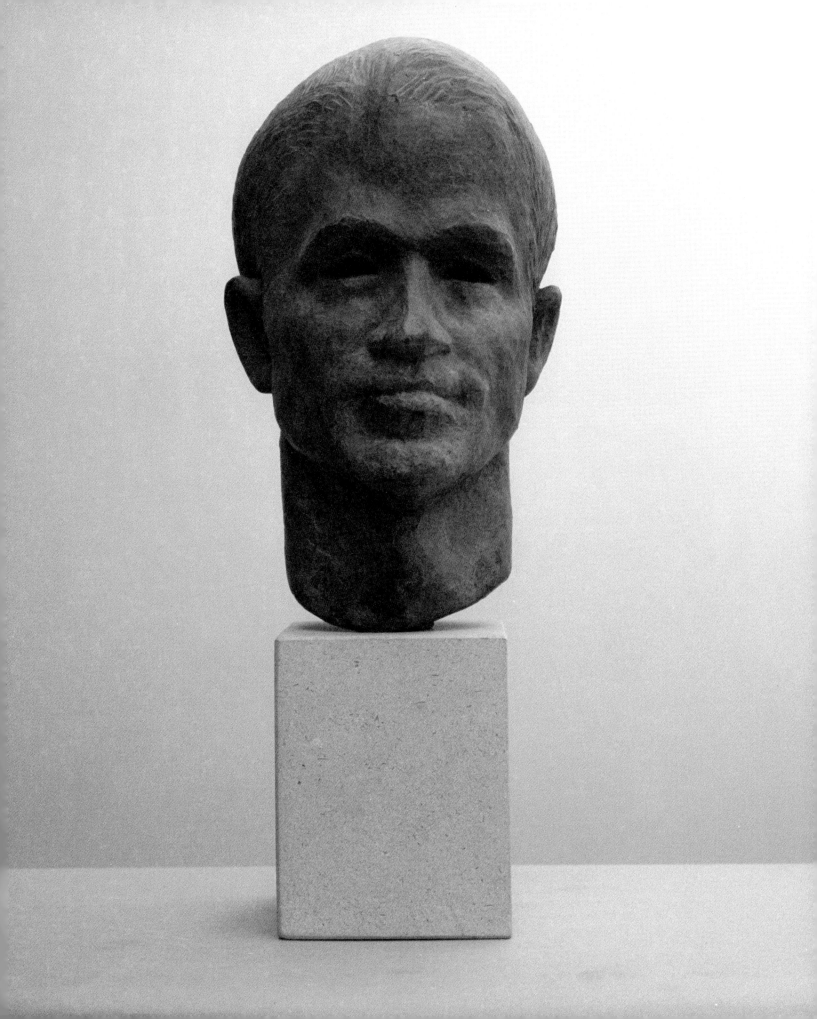

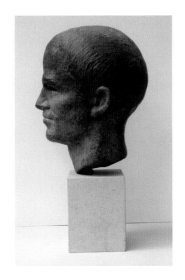

Opposite: Harry Wilson, working clay in process.

Left: Harry Wilson, 2004, bronze on Portland stone.

Right: Harry Wilson, preparatory drawing, 2003, Celia Scott, pencil on paper.

Lucy-May

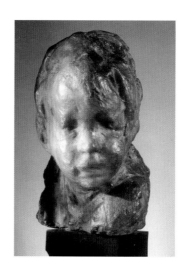

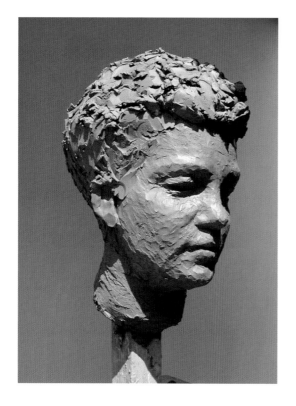

Lucy came for eight or nine sittings and seemed to change even between meetings. It was hard to catch.

I had started this series of heads with the idea of revitalising the tradition of the public role of portrait busts but now my journey was taking me more and more into the realm of private emotions. I avoided taking on any more commissions. On the one hand, I was doing preparatory drawings for war reliefs, and on the other domestic drawings of family. I decided to do a portrait of my husband's young grand-daughter, Lucy-May. As with the head of Harry, this would have to be a likeness, but without the heavy references present in my former works. Lucy came for eight or nine sittings and seemed to change even between meetings. It was hard to catch. There was a stage when the head had some poignancy, before the final cast, then it became more of a likeness, when compared to the actuality, but to me less interesting. It seemed to have lost some the feeling of vulnerability of youth that it once had. It was cast in Ferracotta, to look like terracotta.

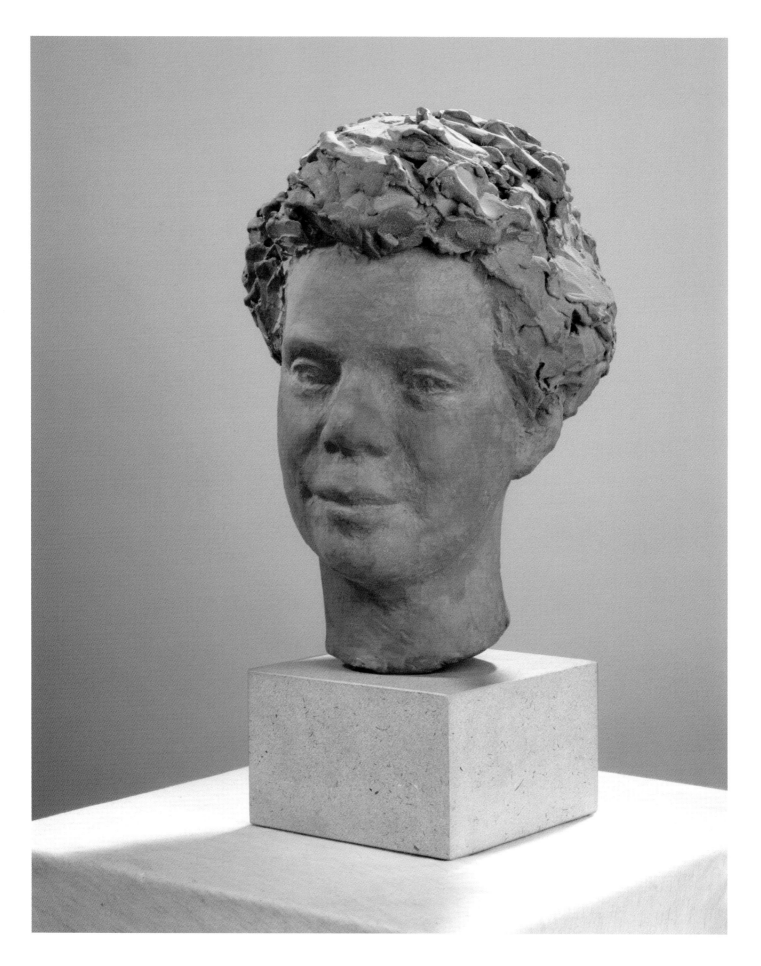

Alistair Clark

Bust of Brutus, detail, Michelangelo.

Opposite: Alistair Clark,
2006, Celia Scott, bronze.

The model here was Michelangelo's bust of Brutus, the rebel who is appropriately portrayed looking over his left shoulder.

Then Charles Jencks approached me to do a head. Charles, with his wife Maggie Keswick, had over many years developed the garden of Portrack House in Scotland. He had now become well known as a landscape designer, using large earth forms. The head he wanted was to commemorate the 60th birthday of his head gardener, Alistair Clark, who had been employed on the estate most of his working life. The gardener was to stand in the gap made by a fallen tree, in a row of cherry trees on the edge of a wood, gazing at the dramatic landform which he had made and tended.

This fitted into my agenda of doing heads of people from all walks of life so I accepted, though now I was not thinking of Balzac's types. I visited the site and spent a weekend measuring, drawing and photographing Alistair. He could not come to London regularly for sittings so I had to work from this material and from memory. I found it very difficult to work without sufficient sittings, especially as I had not known Alistair before. But by now my eye and memory were better trained and finally I was able to complete the head with just two further brief sittings in London. Perhaps it looks more life-like than the other heads.

I tried to acknowledge the pull of the view by slightly twisting his shoulders so that he appears to be looking towards the mounds he created and tends. The model here was Michelangelo's bust of Brutus, the rebel who is appropriately portrayed looking over his left shoulder.

Alistair Clark on pedestal, Celia Scott, 2006. The pedestal was designed by Charles Jencks.

Opposite top: Alistair Clark, preparatory drawings, 2005, charcoal on tracing paper.

Opposite bottom: Alistair Clark on pedestal, 2006, fibrepoint pen on paper.

Eric Parry

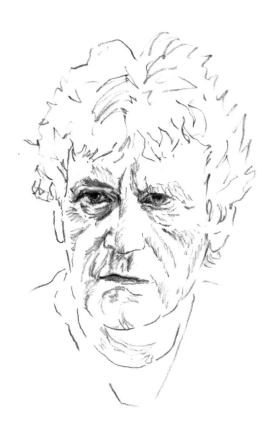

I was intrigued by the idea that restrictions may work to increase the depth of thought, this was something I was trying to do myself.

Eric Parry is an architect who taught at Cambridge, where he knew Sandy Wilson and Dalibor Vesely. So my interest in Eric was partly that he knew my friends and partly that I admired his theoretical interests.

Eric is an architect who wants to be modern, while also linking with humanistic culture, but he was also a member of a younger generation. I thought he had an interesting, rather romantic, head. Perhaps I was thinking of Delacroix's painting of Chopin. There is a fascination about a character who looks poetic even though he makes his living doing buildings, which from my own experience I know to be a very restrictive field. How could he work in this way and still look interesting? This is quite the reverse of TS Eliot, who looked like a bank manager and wrote great poetry.

I was intrigued by the idea that restrictions may work to increase the depth of thought, this was something I was trying to do myself. His architecture is not wild, it comes within the limits of public acceptance, so he must have thought about these aspects himself.

I completed the bust after just six sittings, and I think it's a good one. He tells me he can see his mother's eyes in it.

Eric Parry, preparatory drawing, 2007, pencil on paper.

Opposite: Eric Parry, detail, 2007, bronze.

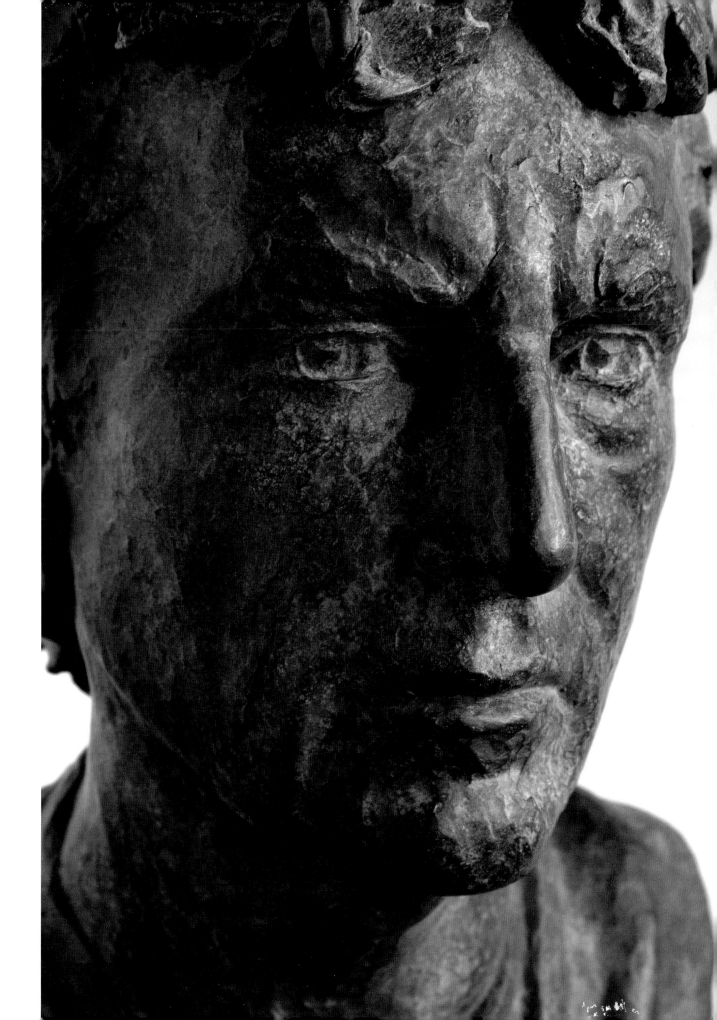

Opposite: Eric Parry, preparatory
drawing, 2007, pencil and crayon
on paper.

Eric Parry, 2007, Celia Scott, bronze,
46 x 27 x 26 cm.

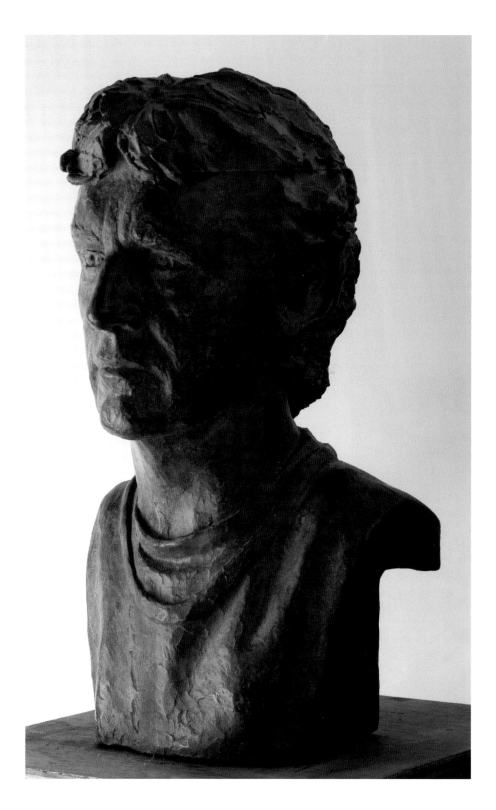

David Attenborough

David Attenborough mould in Arch
Bronze Foundry, 2007.

Opposite: David Attenborough, 2007,
Celia Scott, bronze, 49 x 33 x 34 cm,
Clare College, Cambridge.

Working on a three-dimensional solid likeness, which is what sculptor does, is different from what a photographer or a painter is doing.

I was beginning to wonder whether my ideas about public sculpture were only really working for a small world of architectural cognoscenti. Was it possible that some of the references to what I had thought was a public language only worked for those in the know? Perhaps this didn't really matter, as there was enough common language generally for the heads to work.

Now I was approached by Clare College Cambridge to do a likeness of an eminent alumnus of the college, David Attenborough. As an ardent viewer of his programmes I could not refuse.

This brings the challenge of how to do a bronze portrayal of someone so well known on screen. How can it be different? What can it say that is not apparent on screen?

I bought a cine camera to see if it would help me to use the media upon which he so frequently appears. It did not help. Gestures on film don't translate well into sculpture. The open mouth, the flailing arms. A smile can so easily turn into a fatuous grin in a likeness. So in order to express his vigour and enthusiasm as displayed on the screen I simply turned his head so that from his proposed position on the college staircase he is looking directly towards you.

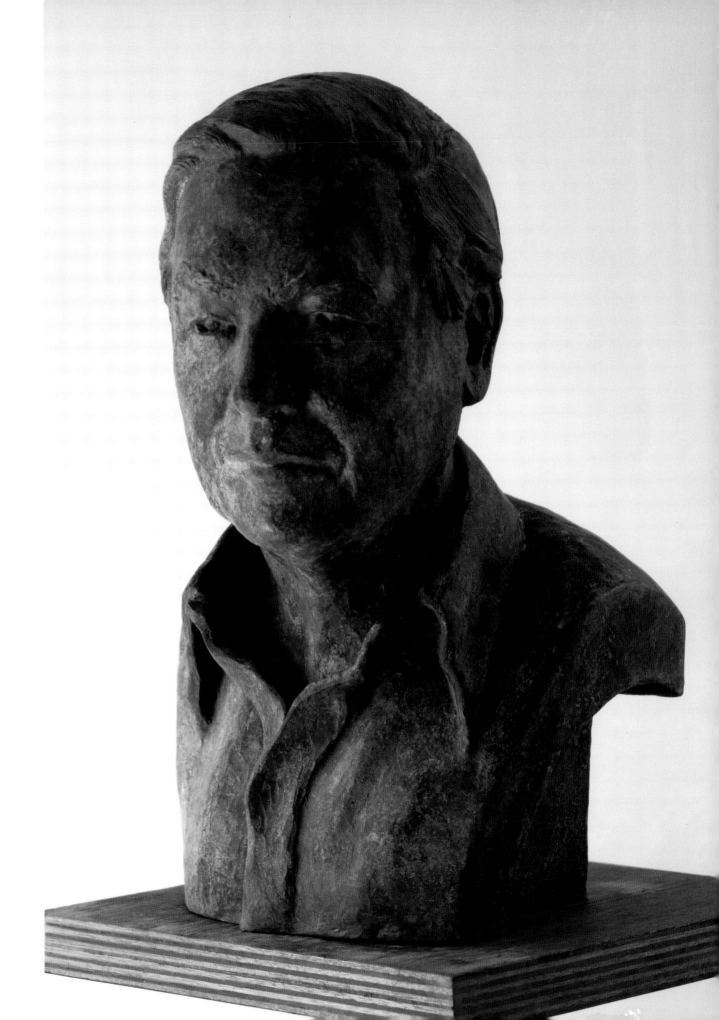

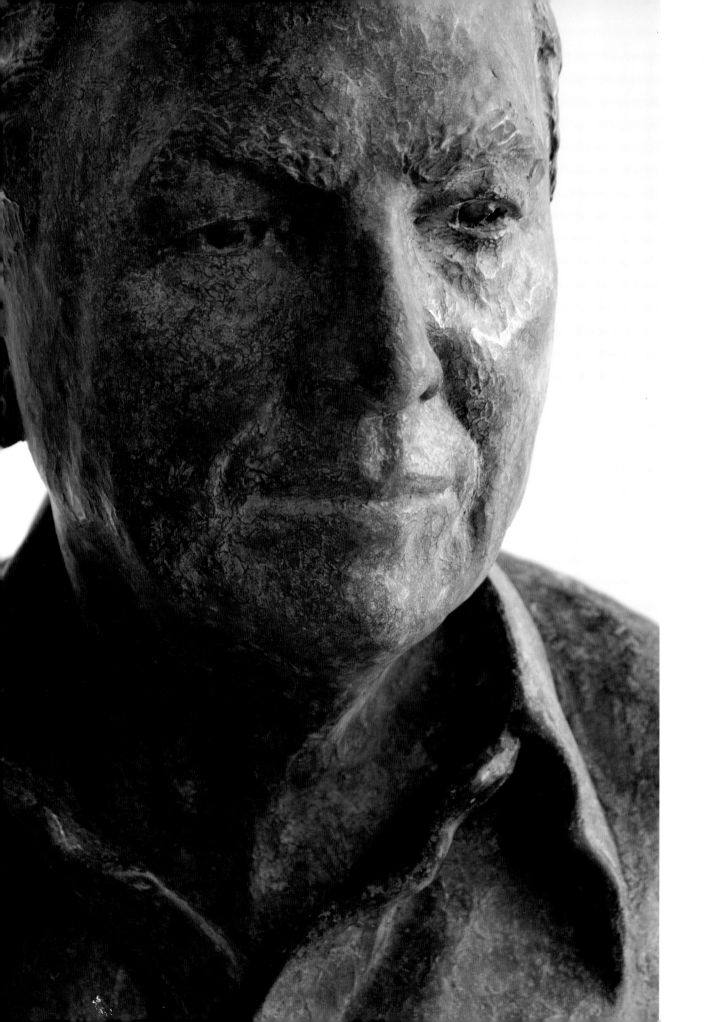

Working on a three-dimensional solid likeness, which is what
a sculptor does, is different from what a photographer or a
painter is doing. Painters may be trying to portray a moment in
time. I am usually trying to make a likeness that is a summary of
moments over time. Also, a painter can hide behind the canvas,
and the sitter need not see what they are doing and may not
see what they are doing until the work is complete. Working
on the clay, I might have to make severe modifications in front
of the sitter, slashing and bashing at the material. This can be
psychologically disturbing and is sometimes better done when
the sitter is absent. I find that now I am using the sittings more
and more to observe and absorb, working on the clay later from
my recordings and from memory.

In the earlier heads it seems to have almost been a collaboration
between myself and the sitters. When I did a person's head,
it was almost like an agreement. I'm not quite sure who
approached whom first, but now in the later heads, people
are approaching me to do portraits.

Opposite: David Attenborough,
detail, 2007, bronze.

David Attenborough, preparatory
drawing, 2007, Celia Scott,
30 x 60 cm.

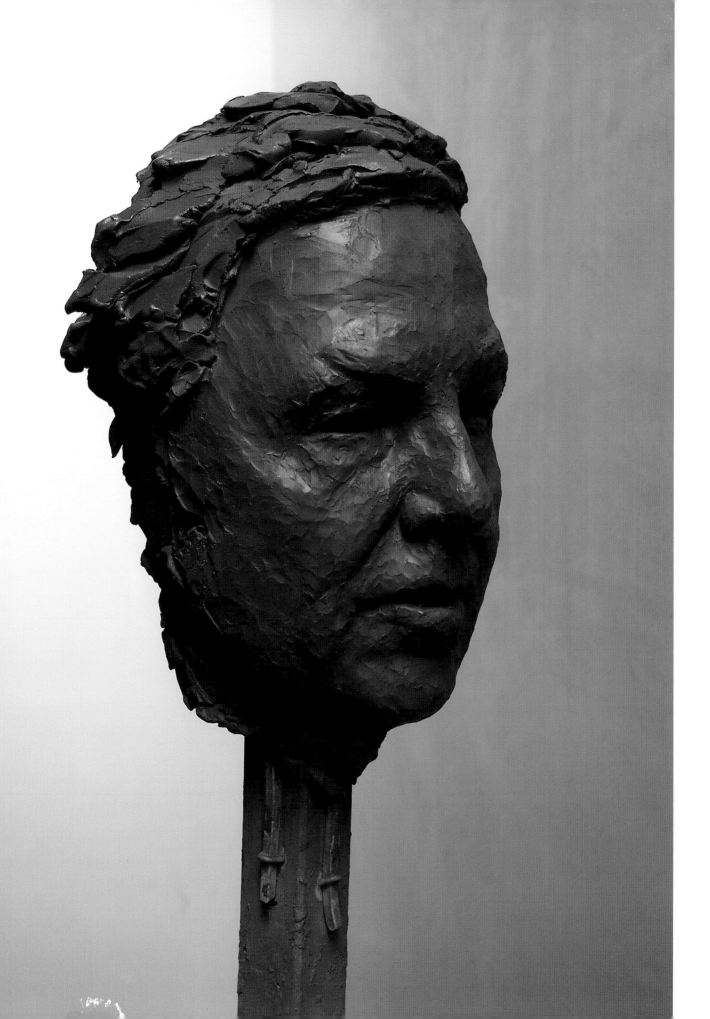

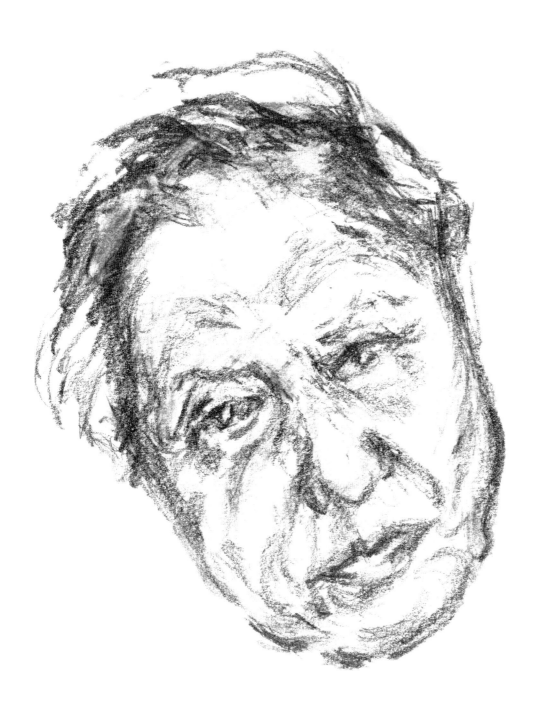

Opposite: David Attenborough,
working clay in process, 2007,
Celia Scott.

David Attenborough, preparatory
drawing, 2007, Celia Scott, pencil
on paper, 42 x 29 cm.

The Next Step

No Man's Land, Isle of Wight, 2007,
Celia Scott, oil on canvas, 40 x 40 cm.

Looking back, my excursion into sculpture and, more specifically, into making likenesses of people, seems now to have been a road accident. I never planned it. My idea in art was rather to be a radical modernist, as I have tried to be in architecture. My career as a portraitist seems to have happened out of a freak chance of knowing Leon Krier just as interest was reviving in ideas of figurative art, with the feeling that abstraction had become too introverted and incomprehensible to ordinary people. This probably is still true, but the impact of figuration seems to have led today to an absolute choice for the artist between being elitist, and misunderstood, or being populist and despised by artists.

In a way my training as an architect led to my undoing because it entailed the discipline of making things 'work'. In other words, it was limited by the theory of functionalism. To get a building built involves participation in a fairly humdrum process of management, which often involves a confrontational relation with a building contractor. Without engaging in this process the design would remain a paper tiger. My experience as an architect led me to an acceptance of this process as normal.

The modern artist doesn't have to compromise in this way. The artist is surely limited by her medium, and in portraiture, the business of achieving a sufficient likeness does tend to limit one's freedom of expression. The process of measuring and drawing a head could be thought of as very similar to the process of doing a measured drawing of a building or a building site. There is a difference, of course, but the business of achieving a likeness to a living person is an empirical constraint for the artist, just as satisfying a client is an empirical constraint for the architect.

The difference for me is that I use measurements as a launching pad for making thousands of small adjustments, some of which are to do with the actuality of the sitter, others of which are to do with the totality of the object taking shape before my eyes. The bust has a presence which is entirely to do with its own completeness, but which is more than the sum of its parts. It takes on the life of an object, and this seems to me make it a modernist object in its own right.

I hope that current studies in drawing and painting will have their effect on my sculpture, and lead to a future less constrained, and more open to the viewer.

> The process of measuring and drawing a head could be thought of as very similar to the process of doing a measured drawing of a building or a building site.

Michael Graves
March 1983
Page 38

Leon Krier
November 1981
Page 18

Alan Coquhoun
June 1983
Page 32

Edward Jones
August 1982
Page 24

Richard Meier
January 1984
Page 70

Rita Wolff
May 1991
Page 74

Mies van der Rohe
Version 2
April 1994
Page 100

1981 1983 1985 1987 1989 1991 1993

John Miller
August 1982
Page 28

James Stirling
September 1983
Page 42

Françoise Choay
October 1987
Page 64

Self Portrait
February 1990
Page 80

Mies van der Rohe
Version 1
April 1993
Page 100

Eduardo Paolozzi
September 1983
Page 50

Peter Eisenman
November 1990
Page 60

Sandy Wilson
Version 1
April 1996
Page 110

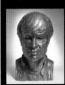

MJ Long
September 1996
Page 116

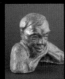

Sandy Wilson
Version 2
October 1998
Page 110

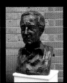

Colin Rowe
May 2000
Page 115

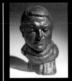

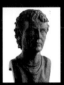

David Attenborough
October 2007
Page 146

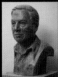

**Richard
Godwin-Austen**
February 2003
Page 130

Eric Parry
October 2007
Page 142

1995 1997 1999 2001 2003 2005 2007

TS Eliot
July 1997
Page 106

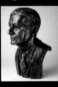

Terry Farrell
April 1999
Page 120

Alister Clark
September 2006
Page 138

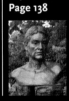

Harry Wilson
April 2004
Page 132

Lucy-May
December 2004
Page 136

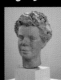

Picture Credits

Cover, inside cover © Peter Cook
11. Photographer Nick Turner, © Celia Scott
12. Photographer Nick Turner, © Celia Scott
13. Photographer Nick Turner, © Celia Scott
14. © Jerry Hardman-Jones
15. © Celia Scott
16. Photographer Nick Turner, © Celia Scott
17. Photographer Nick Turner, © Celia Scott
19. © Jerry Hardman-Jones
20. (right top) © National Archaelogical Museum, Athens, Greece/ Lauros / Giraudon / the Bridgeman Art Library
20. (right bottom) © BPK, Berlin
21. (top) © Robert Maxwell
21. (bottom) © Celia Scott
22. (top) photograph Andrew Lawson © AG Carrick
22. (middle) © Jerry Hardman-Jones
22. (bottom) © Musee des Beaux-Arts, Dijon, France/ Lauros / Giraudon/ The Bridgeman Art Library
23. © Jerry Hardman-Jones
24. © Rhodes Archaeological Museum
25. © Jerry Hardman-Jones
26. © Jerry Hardman-Jones
27. (left) © John Hopkins / Redferns / MUSICPICTURES.COM
27. (right) © Bevington
28. © Celia Scott
29. © Jerry Hardman-Jones
30. © Frank Thurston
31. © Celia Scott
33. © Jerry Hardman-Jones
34. Photographer Nick Turner, © Celia Scott
35. Photographer Nick Turner, © Celia Scott
36. (left) Photographer Nick Turner, © Celia Scott
36. (right) Photographer Nick Turner, © Celia Scott
37. © Jerry Hardman-Jones
38. © Jerry Hardman-Jones
39. © Jerry Hardman-Jones
40. © Celia Scott
41. © Celia Scott
43. © Country Life
44. © Jerry Hardman-Jones
45. (left) © Robert Maxwell
45. (right) © Celia Scott
46. © Sandra Lousada
47. (top) © Celia Scott
47. (bottom) © Sandra Lousadra
48. © Celia Scott
49. © Frank Thurston
50. © Jerry Hardman-Jones
52. © Jerry Hardman-Jones
53. (top) © Marvel Comics
53. (bottom) Photographer: Jonty Wilde © Elisabeth Frink
54. © Celia Scott
55. © Celia Scott
56. © Celia Scott
59. © Celia Scott
60. © Celia Scott

61. © Celia Scott
62. © Celia Scott
64. © BPK Berlin
65. © Jerry Hardman-Jones
66. © Celia Scott
67. (top) © Bargello, Florence, Italy / the Bridgeman Art Library
67. (bottom) © Peter Cook
68. (left) © Kunst Historiches Museum
68. (right) © Celia Scott
69. © Celia Scott
71. © Celia Scott
72. © Jerry Hardman-Jones
74. © Marianne Majerus
75. © Frank Thurston
77. © Celia Scott
78. (left) © Galleria D'Arte Moderna / Saporetti
78. (right) © Art Resource
79. © Jerry Hardman-Jones
80. © Lee Funnell
81. (left) © The Trustees of the British Museum
81. (right) © Frank Thurston
83. © Frank Thurston
85. © Robin Barton
86. (bottom) © D James Dee
88. © Frank Thurston
89. © D James Dee
90. © D James Dee
92. © V&A Images / Victoria and Albert Museum
93. © Lucian Freud, courtesy of the artist
94. © ADAGP, Paris and DACS, London 2007
96. © ARS, NY and DACS, London 2007
97. © Roland Halbe
99. © ARS, NY and DACS, London 2007
100. © Herr Schmidt
101. © Celia Scott
102. (top) Photographer Nick Turner, © Celia Scott
102. (bottom) © Photo RMN / Centre Pompidou
104. © Celia Scott
105. © Jerry Hardman-Jones
106. © Celia Scott
107. © Frank Thurston
109. © Frank Thurston
110. (left) © Celia Scott
110. (right) © ADAGP, Paris and DACS, London 2007
111. © Jerry Hardman-Jones
112. (left) © Vanni / Art Resource NY
112 (right) © Frank Thurston
114. © Frank Thurston
115. © Celia Scott
116. © Frank Thurston
117. © Peter Cook
118. (left) © Lee Funnell
118. (right) © Celia Scott
119. © Frank Thurston
120. © Alinari / Art Resource NY
121. © Frank Thurston
122. © Celia Scott

123. Frank Thurston
124. © Peter Cook
125. © Peter Cook
126. © Celia Scott
127. © Peter Cook
128–129 © Celia Scott
130. © Celia Scott
131. © Celia Scott
133. © Celia Scott
134. © Celia Scott
135. (left) © Celia Scott
136. (left) © Musee d'Orsay, Paris, France/ The Bridgeman Art Library
136. (bottom) © Celia Scott
137. © Jerry Hardman-Jones
138. © Bargello, Florence, Italy/ The Bridgeman Art Library
139. © Jerry Hardman-Jones
140. © Jerry Hardman-Jones
143. © Sandra Lousada
145. © Sandra Lousada
146. © Arch Bronze Foundry
147. © Sandra Lousada
148. © Sandra Lousada
150. © Celia Scott
153. Photographer Nick Turner, © Celia Scott
Inside Cover: © Peter Cook

Foundry Credits

Leon Krier, 1981, 2 bronze casts, Richard Cowdy, Wiltshire
Edward Jones, 1982, 2 bronze casts, Meridian, London
John Miller, 1982, 2 bronze casts, Art Bronze, London
Michael Graves, 1983, 2 bronze casts, Tallix, Peekskill, New York
Alan Colquhoun, 1983, 2 bronze casts, Tallix, Peekskill, New York
James Stirling, 1983, 2 bronze casts. Art Bronze, London
Eduardo Paolozzi, 1983, 1 bronze cast, Art Bronze, London
Hephaestus, 1983, 1 bronze cast, Royal College of Art, London
Françoise Choay, 1986, 1 bronze cast, Johnson Atelier, Mercerville, New Jersey
Richard Meier, 1987, 1 bronze cast, Tallix, Beacon, New York
Peter Eisenman, 1990, 1 iron cast, Johnson Atelier, Mercerville, New Jersey
Rita Wolff, 1984, 1 plaster cast, A & A Casting, London
Self Portrait, 1990, 2 hydrocal casts,

Johnson Atelier, Mercerville, New Jersey
Mies van der Rohe, version 1, 1993, 1 bronze cast,
Arch Bronze, London
Mies van der Rohe, version 2, 1994, 1 bronze cast,
Arch Bronze, London
Sandy Wilson, version 1, 1996, 1, cast,
Arch Bronze, London
Sandy Wilson, version 2, 1996, 2 bronze casts,
Arch Bronze, London
TS Eliot, 1997, 2 bronze casts,
Arch Bronze, London
MJ Long, 1996, 1 bronze cast,
Arch Bronze, London
Terry Farrell, 1999, 1 bronze cast, 1 ferracotta cast,
Arch Bronze, London
Richard Godwin-Austen, 2003, 1 bronze cast,
Arch Bronze, London
Harry Wilson, 2004, 1 bronze cast,
Arch Bronze, London
Lucy-May, 2004, 1 ferracotta cast,
Arch Bronze, London
Alistair Clark, 2006, 1 bronze cast,
Arch Bronze, London
Eric Parry, 2007, 1 bronze cast,
Arch Bronze, London
David Attenborough, 2007, 1 bronze cast,
Arch Bronze, London
Scanning by David Cutts at The DPC

Acknowledgements

I wish to give particular thanks to Alan
Colquhoun for his article, to Lucian Freud
for allowing me to use the image of his
self-portrait, to Duncan McCorquordale for
initiating the book, to Nadine Monem for
editing it, to Michael Spens for his comments
and to Julia Morlok for bringing it to life.

Finally, I wish to give special thanks to my
husband Robert Maxwell for his unstinting
help, encouragement and support.

Black Dog Publishing
Architecture Art Design Fashion History
Photography Theory and Things

©2008 Black Dog Publishing Limited, London, UK, the authors
and the artists. All rights reserved

Texts by Celia Scott and Alan Colquhoun

Edited by Nadine Käthe Monem
Picture Research by Nikos Kotsopoulos

Designed by Julia Morlok with support from
Emily Chicken and Matthew Pull at BDP.

Black Dog Publishing Limited
10A Acton Street
London, WC1X 9NG
www.blackdogonline.com

Black Dog Publishing is an environmentally responsible
company. *Celia Scott* is printed on Sappi Magno Satin,
a chlorine-free FSC certified paper.

architecture art design
fashion history photography
theory and things

**black dog
publishing**

www.blackdogonline.com
london uk